59.972

12466
12.99

Frida

Kahlo

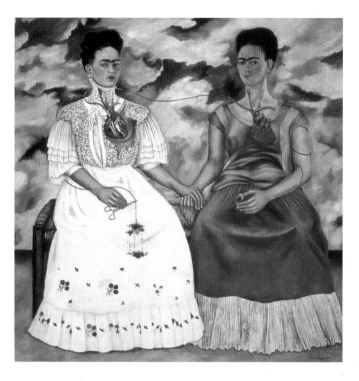

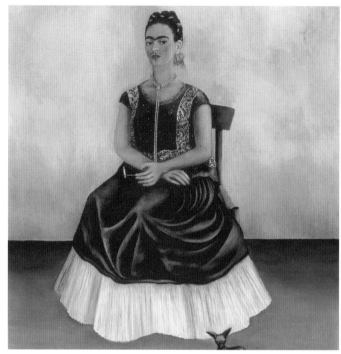

ISBN 1-84013-761-4

Published in 2005 by Grange Books
an imprint of Grange Book Plc
The Grange Kingsnorth Industrial Estate
Hoo, nr Rochester, Kent ME3 9ND
www.Grangebooks.co.uk

Printed in China

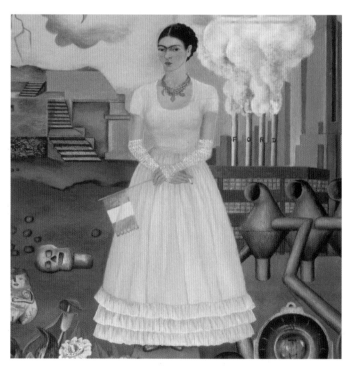

Frida

Kahlo

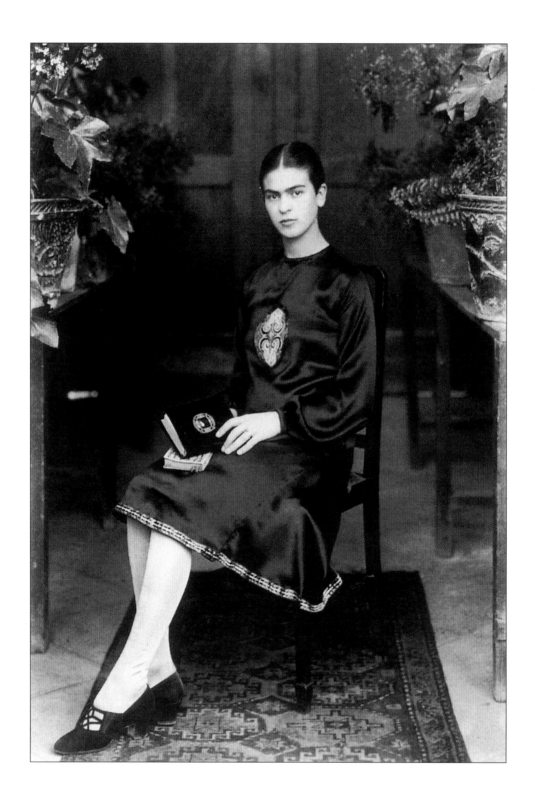

The painter and the person are one and inseparable and yet she wore many masks. With intimates, Frida dominated any room with her witty, brash commentary, her singular identification with the peasants of Mexico and yet her distance from them, her taunting of the Europeans and their posturing beneath banners: Impressionists, Post-Impressionists, Expressionists, Surrealists, Social Realists, etc. in search of money and rich patrons, or a seat in the academies. And yet, as her work matured, she desired recognition for herself and those paintings once given away as keepsakes. What had begun as a pastime quickly usurped her life. Her internal life caromed between exuberance and despair as she battled almost constant pain from injuries to her spine, back, right foot, right leg, plus fungal diseases, many abortion viruses and the continuing experimental ministrations of her doctors. The singular consistent joy in her life was Diego Rivera, her husband. She endured his infidelities and countered with affairs of her own on three continents, consorting with both strong men and desirable women. But in the end, Diego and Frida always came back to each other. Diego stood by her at the end as did a Mexican but was slow to realize the value of its treasure. Denied singular recognition by her native land until the last years of her life, Frida Kahlo's only one-person show in Mexico opened where her life began.

Magdalena Carmen Frida Kahlo y Calderón was born on July 6, 1907, in Coyoacán, Mexico. Her mother, the former Matilde Calderon, a devout Catholic and a *mestiza* of mixed Indian and European lineage, held deeply conservative and religious views of a woman's place in the world. On the other hand, Frida's father was an artist and photographer of some note who pushed her to think for herself. Amidst all the traditional domesticity, he fastened onto Frida as a surrogate son who would follow his steps into the creative arts. He became her very first mentor that set her aside from traditional roles accepted by the majority of Mexican women. She became his photographic assistant and began to learn the trade.

Frida Kahlo was spoiled, indulged and impressionable. In 1922, to assure her a better than average education, she was also entered into the free National Preparatory School in San Ildefonso. She devoured her new freedom from mind-numbing domestic chores and hung out with a number of cliques within the school's social structure. She found a real sense of belonging with the *Cachuchas* gang of intellectual bohemians – named after the type of hat they wore. Leading this motley elitist mob was Alejandro Gomez Arias, who reiterated in countless speeches that a new enlightenment for Mexico required "optimism, sacrifice, love, joy" and bold leadership. She remained a committed and vocal Communist for the rest of her life.

1. Frida Kahlo at the age of 18 years, 1926. Photography by Guillermo Kahlo.

The atmosphere in Mexico City was alive with political debate and danger. Volatile speakers stepped forward to challenge whatever regime claimed power only to be gunned down in the street, or be absorbed into the corruption. Diaz fell to Madero who lasted 13 months until he stopped a lethal load of bullets from his general Victoriano Huerta.

Later, Venustiano Carranza assumed power as Huerta fled Mexico, and was no better than the lot who had preceded him. Into this vacuum were thrust the proletarian ideals of the Communist revolution that had swept Russia following the assassination of the Czar and his family in 1917. The socialist theories of Marx and Engels looked promising after the slaughter of the seemingly endless Mexican revolution.

And yet, for all this progressive political dialectic and debate, Frida retained some of her mother's Catholic teachings and developed a passionate love of all things traditionally Mexican. During this time, her father gave her a set of water colors and brushes. He often took his paints along with his camera on expeditions and assignments.

Frida became a casual student at the Preparatory School, enjoying the stimulation of her intellectual friends rather than the formal studies. During this period, she learned the minister of education had commissioned a large mural to be painted in the Preparatory School courtyard. It was titled *Creation* and covered 150 square meters of wall. The muralist was the Mexican artist, Diego Rivera who had been working in Europe for the past fourteen years. To Frida, the creation of the growing scene spreading its way across the blank wall was fascinating. She and some friends often sneaked into the auditorium to watch Rivera work.

From a very early age, Frida had been taught by her father to appreciate the art of painting. As part of her education he encouraged her to copy the popular prints and drawings of other artists. To ease the financial situation at home, she apprenticed with the engraver, Fernando Fernandez. Fernandez praised her work and gave her time to copy prints and drawings with pen and ink – as a hobby, a means of personal expression, not as "art" because she had no thought of becoming a professional artist. She considered the skills of artists such as Diego Rivera far beyond her capabilities.

And then everything changed forever. In Kahlo's words to author, Raquel Tibol:

> "The buses in those days were absolutely flimsy; they had started to run and were very successful, but the streetcars were empty. I boarded the bus with Alejandro Gomez Arias and was sitting next to him on the end next to the handrail. Moments later the bus crashed into a streetcar of the Xochimilco Line and the streetcar crushed the bus against the street corner. It was a strange crash, not violent, but dull and slow, and it injured everyone, me much more seriously…"

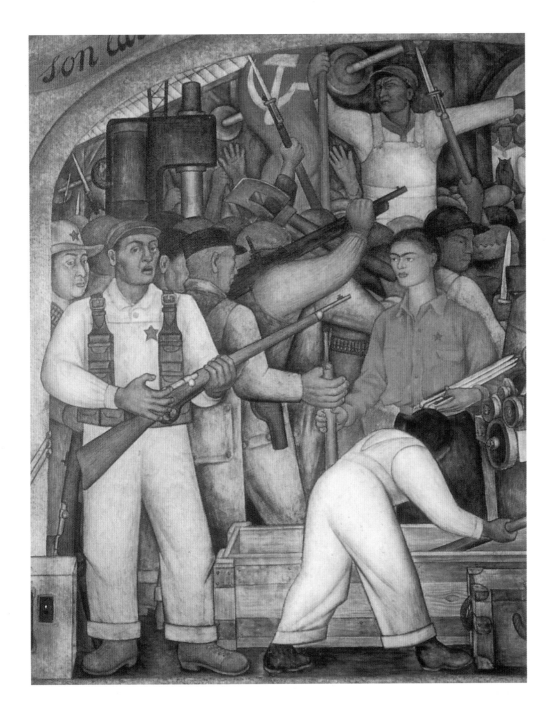

2. *Arsenal – Frida Kahlo*
 distributing weapons.
 Detail from the cycle
 Political Ideal of the
 Mexican people
 (in the *Fiesta Court*),
 1928. 2.03 x 3.98 m.
 Secretaría de
 Educación Pública-SEP,
 Mexico City.

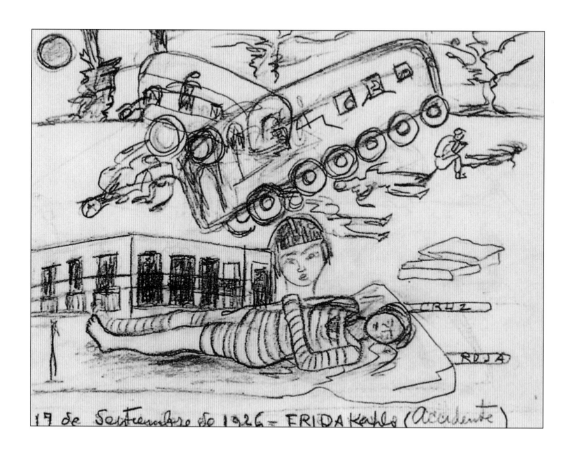

17 de Septiembre de 1926 - FRIDA Kahlo (accidente)

3. *Accident*, 1926. Pencil on paper, 20 x 27 cm. Coronel Collection, Cuernavaca, Morelos.

The scene of the accident was gruesome. The iron handrail had stabbed through her hip and emerged through her vagina. A fount of blood hemorrhaged from her wound. In the chaos, one bystander insisted the hand rail be removed from her. He reached down and tore it from the wound. She screamed so loud the approaching ambulance siren could not be heard.

The devastation to Frida Kahlo's body can only be imagined, but its implications were far worse once she realized she would survive. This vital vivacious young girl on the brink of any number of career possibilities had been reduced to a bed-bound invalid. Only her youth and vitality saved her life. Her father's ability to earn enough money to feed his family and pay Frida's medical bills had diminished with the Mexican economy. This necessitated lengthening her stay in the overburdened, undermanned Red Cross hospital for a month.

After being pinned to her bed, swathed in plaster and bandages, she was eventually allowed to go home.

Gradually, her indomitable will asserted itself and she began to make decisions within the narrow view she commanded. By December, 1925, she regained the use of her legs. One of her first painful journeys was to Mexico City. Shortly thereafter, she was felled by shooting pains in her back and more doctors trooped into her life. Her three undiagnosed spinal fractures were discovered and she was immediately encased in plaster once again.

Trapped and immobilized after those brief days of freedom, she began realistically narrowing her options. As days of soul searching continued, she passed the time painting scenes from Coyoacán and portraits of relatives and her friends who came to visit.

The praise her paintings elicited surprised her and she began deciding who would receive the painting before she started. She gave them away as keepsakes. With these paintings, she began a remarkable lifetime series of fully realized Frida Kahlo reflections, both introspective and revealing, that examined her world from behind her own eyes and from within that crumbling patchwork of a body.

By 1928, Frida had recovered enough to set aside her orthopedic corsets and escape the narrow world of her bed to walk out of *La Casa Azul* once again into the social and political stew that was Mexico City. She began re-exploring the heady world of Mexican art and politics.

She wasted no time in hooking up with her old comrades from the various cliques at the Preparatory School. Soon, as she drifted from one circle to another; she fell in with a collection of aspiring politicians, anarchists and Communists who gravitated around the American expatriate, Tina Modotti. During the First World War and the early 1920s, many American intellectuals, artists, poets and writers fled the United States to Mexico and later to France in search of cheap living and political idealism. They banded together to praise or condemn each other's works and drafted windy *manifestos* while participating in one long inebriated party that lasted several years, lurching from apartment to salon to saloon and back. These expatriates fashioned a sentimental vision of the noble peasant toiling in the fields and promoted the Mexican view of life as *fiestas y siestas* interrupted by the occasional bloody peasant revolt and a scattering of political assassinations.

Into this tequila-fueled debating society stepped the formidable presence of Diego Rivera, the prodigal returned home from 14 years abroad and having been kicked out of Moscow. Despite his rude treatment at the hands of Stalinist art critics and the Russian government's unveiled threats of harm if he did not leave, Diego embraced Communism as the world's salvation. Soon after his arrival in 1921, he sought out pro-Mexican art movements, Mexican muralists and easel painters, photographers, and writers.

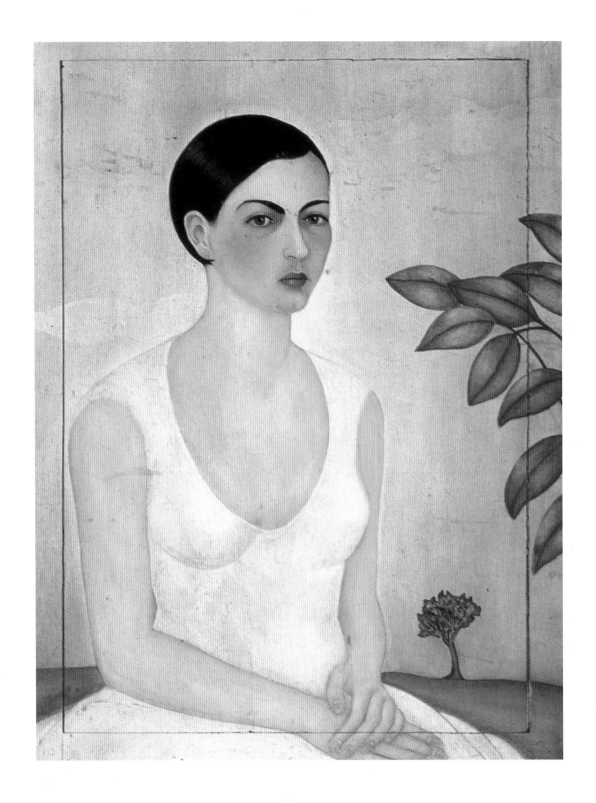

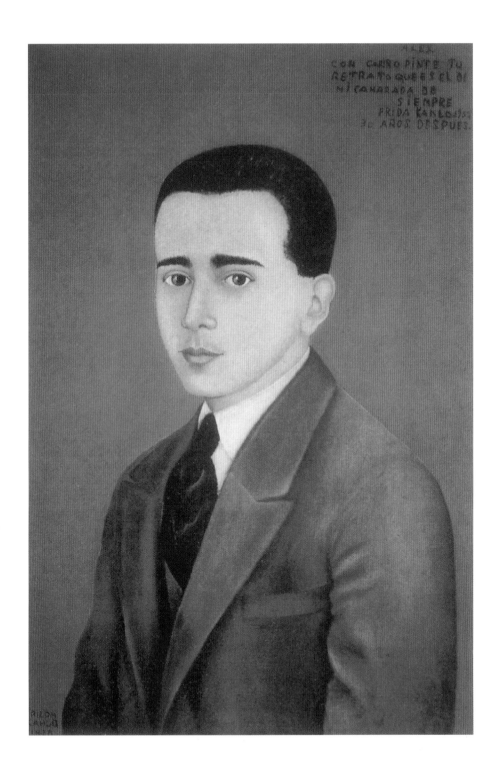

4. *Portrait of My Sister Cristina*, 1928. Oil on wood, 99 x 81.5 cm. Collection Otto Atencio Troconis, Caracas.

5. *Portrait of Alejandro Gómez Arias*, 1928. Oil on canvas. Bequest of Alejandro Gómez Arias, Mexico City.

Within this deeply Mexicanistic society, Tina Modotti's circle of expatriates and fellow travelers fit right in to the party circuit.

Frida drifted into this stimulating circle. As Frida recalled her first meeting with her future husband:

> *"We got to know each other at a time when everybody was packing pistols; when they felt like it, they simply shot up the street lamps in Avenida Madero. Diego once shot a gramophone at one of Tina's parties. That was when I began to be interested in him although I was also afraid of him."*

And Diego saw the same flash in the school girl who had stood eye to eye with his now ex-wife, Lupe Marin, and held her ground. This was more than a spoiled child of the bourgeoisie. She challenged him, and Diego Rivera, ever the swordsman, never refused a challenge. His original interest in the cheeky young girl, whose feisty attitude had charmed him, turned to a deeper respect, an appreciation of her as a fellow artist to whom he could relate on many different levels. It was not long before he began showing up at *La Casa Azul* every Sunday. Diego had become a courting suitor.

On August 21, 1929, Frida Kahlo, age 22, married Diego Rivera, age 42, in a civil ceremony, joined by a few close friends at the Coyoacán City Hall. Adopting her role as the good wife, Frida brought Rivera his lunch at the scaffolding each day. With her duties as Rivera's doting wife claiming more of her time, she virtually stopped painting. In 1929, however, she did manage to creatively put her psychological house in order. One canvas seems to mark a step in distancing herself from the cause of her physical turmoil. She painted *The Bus*.

In December 1930, Rivera received a commission from the United States. Frida accompanied Diego and established their quarters in a weekend house. This time, she spent considerable time at the project watching Diego work and offering the occasional question or critique. Diego found many of her suggestions to be helpful. He came to be influenced by her ideas throughout the rest of their relationship. By this time, the Communist Party had its fill of Diego Rivera. Though he had held office in the party and showed solidarity at their rallies, his casual acceptance of commissions from capitalists went against the grain of the conservative ideologues.

In 1929, he was booted from the party and, demonstrating her loyalty to him, Frida quit too. Neither abandoned the goals of Communism and continued to espouse its anti-capitalist causes, but their support came from the sidelines.

6. *Frida and Diego Rivera or Frida Kahlo and Diego Rivera*, 1931. Oil on canvas, 100 x 79 cm. San Francisco Museum of Modern Art, Albert M. Bender Collection, donation by Albert M. Bender, San Francisco.

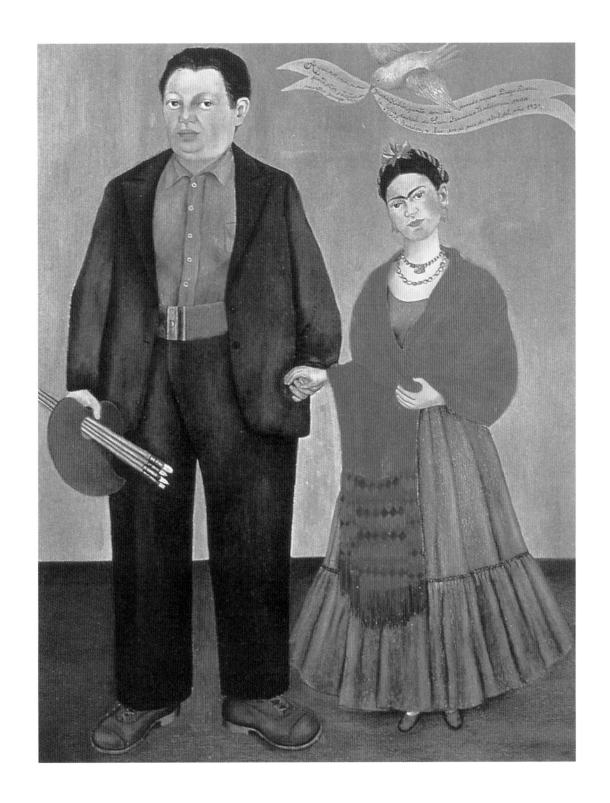

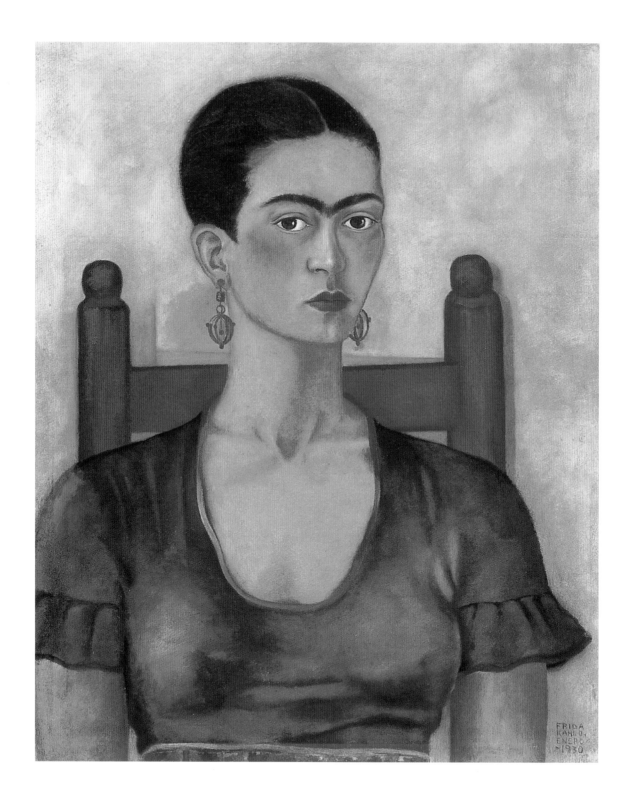

In Cuernavaca, Frida experienced a miscarriage three months into her first pregnancy. This devastating event was topped shortly thereafter when she discovered Diego had been having an affair with one of his female assistants.

At the close of the 1920s, Mexico's political climate shifted again and Diego found himself caught in the middle of an ideological battle. Not only was he *persona non grata* at Communist Party Headquarters, but the government had grown tired of seeing socialist themes peering back from "historic" murals popping up all over the country. Feeling the heat on the back of his neck, Rivera accepted some commissions in San Francisco, packed up his brushes and Frida and headed for the United States.

She arrived in the United States as the Great Depression began settling in, wiping out fortunes, closing banks, and chasing farmers off their land with foreclosures nailed to farmhouse doors. But still, there was money for murals and for welcoming parties among San Francisco's society set where they lionized Diego and scrutinized Frida. She was, for all her philosophical reading and political rhetoric, a provincial girl of 23 on her first trip away from home and friends. She avoided the people of San Francisco, finding them "boring" and with faces like "unbaked biscuits." Her health also took another turn for the worse. The tendons in her right foot and ankle became irritated and she found walking difficult. She decided to consult a San Francisco physician and friend of Rivera's, Doctor Leo Eloesser.

The doctor and the artist immediately struck up a friendship. Besides determining that Frida had scoliosis, a congenital spinal deformation, he also discovered what he interpreted to be a connection between the return of her leg and foot problems and the stress of her chaotic emotional life. As small and large crises occurred, such as Diego's latest public dalliance, her physical problems manifested themselves. Eloesser recommended a healthy living regimen to calm both her physical and mental agonies. She kept up their friendship, but ignored his advice. Instead, she turned to her art and a series of portraits. Frida produced a masterpiece of her own. She painted a portrait of Luther Burbank, the famous horticulturist whose 53 years of cross-breeding plant species had made a huge contribution to California's agriculture.

Other than her shopping trips to Chinatown where she loved to observe the Chinese children, Frida found San Francisco unremarkable. She did not take advantage of its urban sprawl nor its scenic bay for subject matter. Adapting to another culture, thrust into an alien milieu where she was an object of curiosity, separated from her friends and relatives and language, all these influences colored her judgments and priorities.

As her loneliness forced her back on her work, she began to consider its value as public art rather than closely held keepsakes for friends. San Francisco's cosmopolitan setting revealed new vistas and possibilities. In a letter to her friend, Isabel Campos, she wrote:

7. *Self-Portrait*, 1930.
 Oil on canvas,
 65 x 55 cm. Museum
 of Fine Arts, Boston.

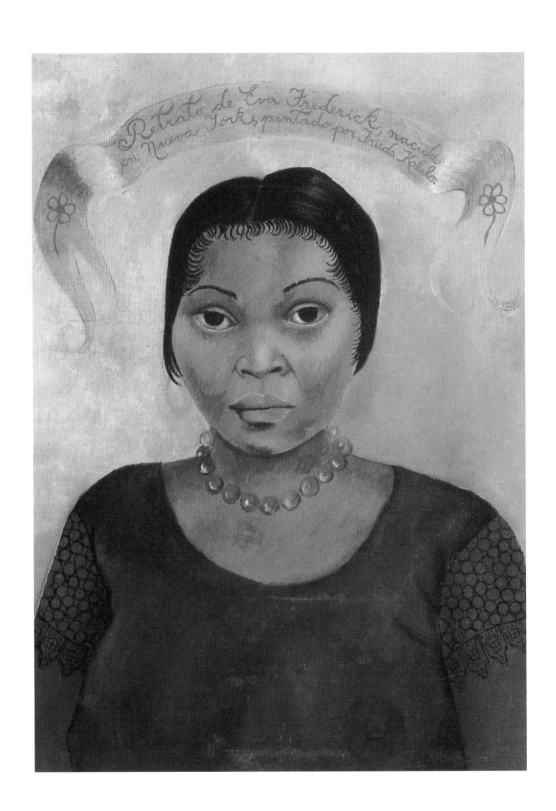

8. *Portrait of Eva
Frederick*, 1931.
Oil on canvas,
63 x 46 cm.
Museo Dolores
Olmedo Patiño,
Mexico City.

9. *Portrait of Dr. Leo Eloesser*, 1931. Oil on masonite, 85.1 x 59.7 cm. University of California, School of Medicine, San Francisco.

"I have no women friends… and that's why I spend my life painting. In September, I'll give a show – the first – in New York. I don't have any time and I could only sell a few pictures here, but it was very good for me to come here anyway, because it opened my eyes, and I saw so very many new and good things."

They had been home only a few months when Diego received an invitation from the Museum of Modern Art in New York to help create a retrospective of his work. Though she faced being torn away from her Mexican roots, this news must have brightened Frida's prospects for a show of her own work. For that, she would once again troop back to "Gringolandia," and hob-nob with the rich boring art and society set that fluttered around Diego. They sailed on the cruise ship *Morro Castle* in mid-November to arrive in Manhattan on December 13, 1931, in time for the December 23 show.

As with San Francisco, upon arrival Diego and Frida were adopted by the rich and famous, by both old and new money, and as before, Diego was the center of the maelstrom. The gallery walls held 150 of his works and showed eight mural panels that Diego had prepared for the exhibition. Art critics traveled to New York from around the country, and the show was a great success.

The petite 24-year-old Mexican girl on Diego Rivera's arm was referred to in the outpouring of prose as "shy" and "retiring" and who, the commentators mentioned in passing, "did a bit of painting herself."

Her quaint rejection of American urban conditions at the start of the Great Depression underscores her own naïve political rhetoric about uplifting the masses, when she never really came into contact with her own poverty-stricken Mexican "masses." But in New York, the vast gap between the chauffeured limousines sailing up and down concrete canyons and bread lines shuffling into store-front soup kitchens must have graphically reinforced Frida's socialist sensibilities. Putting down her American hosts might also have been a side effect of being ignored as an artist in her own right yet again. She continued to be "Mrs. Rivera." Children were on Frida's mind. She had scarcely unpacked when she discovered she was pregnant. The idea both pleased and terrified her. She had always loved children and had a deep maternal instinct that she had lavished on Diego. But she feared her heredity and her ability to carry the pregnancy to term.

Her conflicts were very real, and if she had any idea that sharing a baby would put an end to Diego's affairs, she was probably wrong. He had already abandoned two children from a previous marriage and rarely saw the daughter born by Lupe Marin.

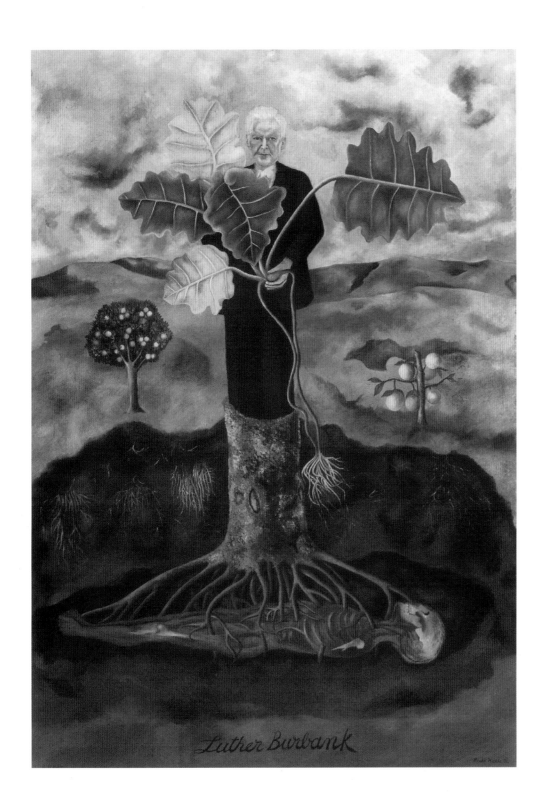

10. *Portrait of Luther
 Burbank*, 1931.
 Oil on masonite,
 86.5 x 61.7 cm.
 Museo Dolores
 Olmedo Patiño,
 Mexico City.

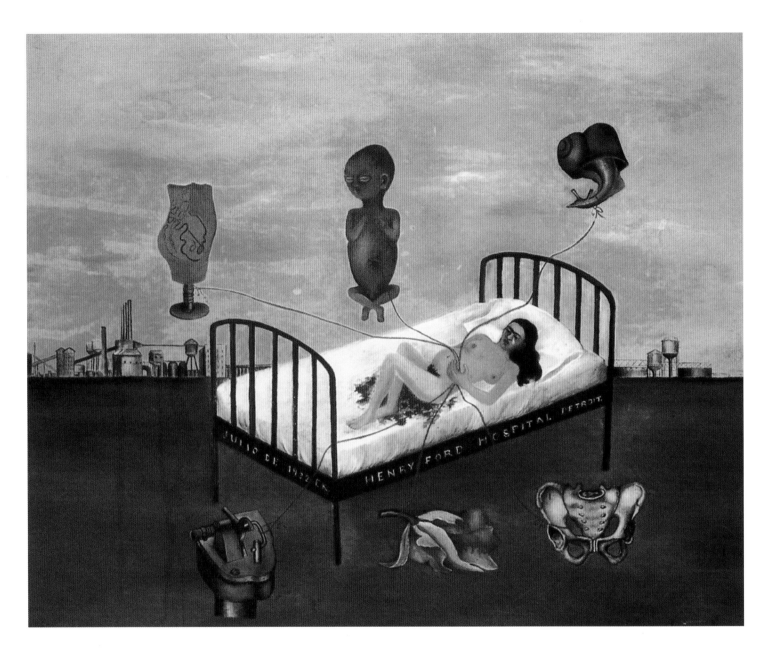

11. Henry Ford Hospital
or The Flying Bed,
1932. Oil on metal,
30.5 x 38 cm.
Museo Dolores
Olmedo Patiño,
Mexico City.

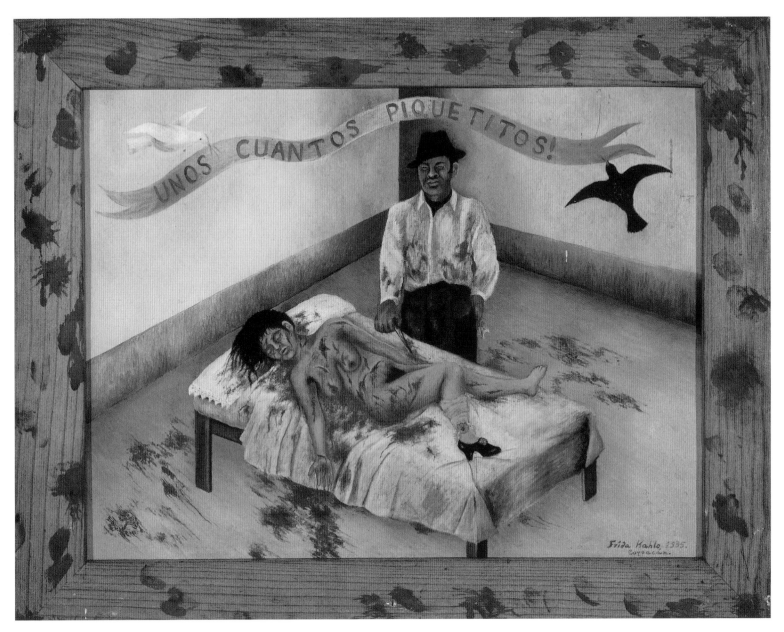

12. *A Few Small Nips*,
 1935. Oil on metal,
 38 x 48.5 cm with
 frame, 29.5 x 39.5 cm
 without frame. Museo
 Dolores Olmedo
 Patiño, Mexico City.

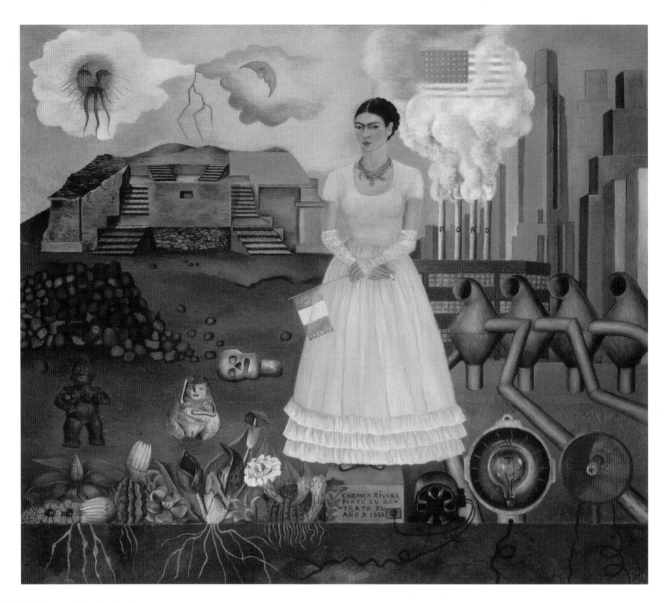

13. *Self-Portrait (standing)*
 along the Border
 between Mexico and
 the United States, 1932.
 Oil on metal,
 31 x 35 cm.
 Collection Manuel
 and Maria Reyero,
 New York.

14. *My Dress Hangs There* or *New York*, 1933. Oil and collage on board, 46 x 50 cm. Hoover Gallery San Francisco, Bequest of Dr. Leo Eloesser.

She also consulted a doctor in Detroit who advised her that the child could be delivered by cesarean section. She decided to have the child. In the fourth month of her pregnancy, July 4, 1932, Frida miscarried. Emotionally and physically drained, she fell back on her only consolation, her painting. She turned her loneliness and depression into creative activity. Only this time, the subjects were far more personal as she scoured her emotions to tell her sad narrative.

As if the miscarriage was not sufficiently crushing, Frida received news from home that her mother was dying of cancer. Still healing from her trauma, Frida had to return to Coyoacán as soon as possible. She arrived in Mexico on September 8, and her mother died on September 15, 1932. By October 21, she was back in Detroit and she learned that Diego had been offered another commission, this time to create a mural in the lobby of the RCA building in New York's Rockefeller Center. Following that, the 1933 World's Fair being held in Chicago wanted a mural on the theme of "machinery and industry." Diego worked himself to exhaustion to complete the Detroit project and had little time for her. Frida took up her brushes to restore her spirits.

New York was in the freezing grip of winter when the Riveras finally unpacked their bags in a suite high above downtown Manhattan. Frida shopped and hung out with friends from their last visit. She rarely painted, but did dab away at one work that remained unfinished when they left New York for Mexico in December, 1933.

As the RCA Building mural proceeded along, word began to leak out that Diego's version of *Men at the Crossroads Looking with Hope and High Vision to the Choosing of a New and Better Future* had a Red in it. Though the sketches had been approved, somehow the sponsors and young Nelson Rockefeller had missed a portrait among the pantheon of faces that gradually took on the likeness of every Capitalists's nightmare, Vladimir Ilyich Lenin.

Ticket sales were cut off, the mural was screened from public view and Rockefeller insisted that Rivera alter the portrait. Not only did Diego refuse, he declared he wanted to finish the work by May Day, the celebration of the Russian Revolution. In a conciliatory move, however, Diego did offer to balance the head of Lenin with a head of Abraham Lincoln of the same size. Shortly thereafter a squad of security guards and the building's rental manager clattered across the lobby's travertine floor, stopped all work on the mural, handed over the balance of money due for the completed mural and bundled Rivera and his band of revolutionaries from the sanctity of Rockefeller Center.

A hew and cry went up to save the mural. Picketing and counter-picketing stopped traffic outside the RCA Building. Artists, intellectuals, political gadflies, pundits, powerful panjandrums, and newspaper editorialists jumped into the war of words.

15. *My Grandparents, My Parents and I*, 1936. Oil and tempera on metal, 30,7 x 34,5 cm. The Museum of Modern Art, donation by Allan Roos, M.D. and B. Roos, New York.

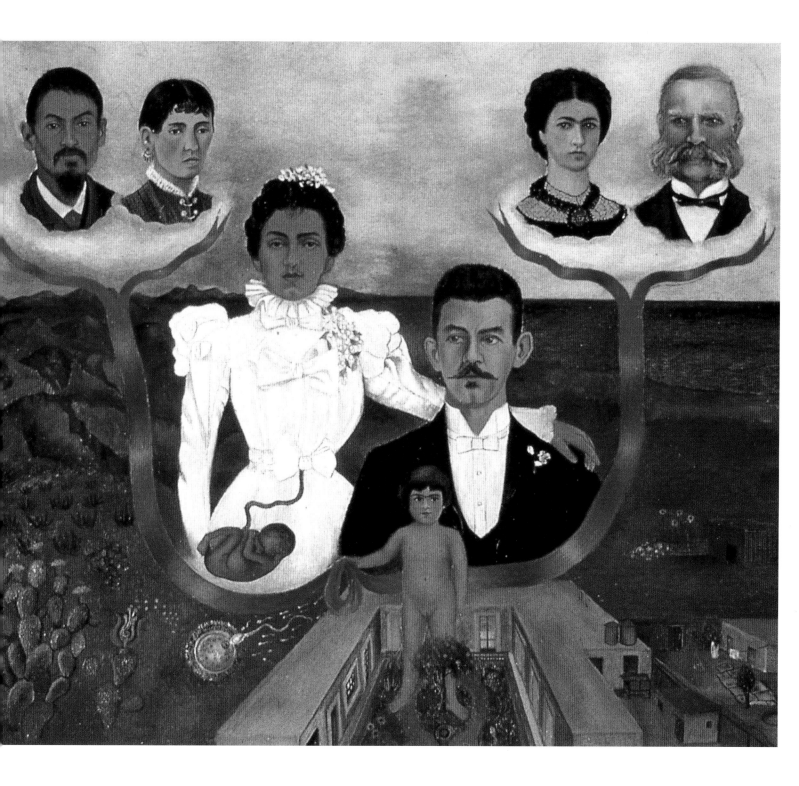

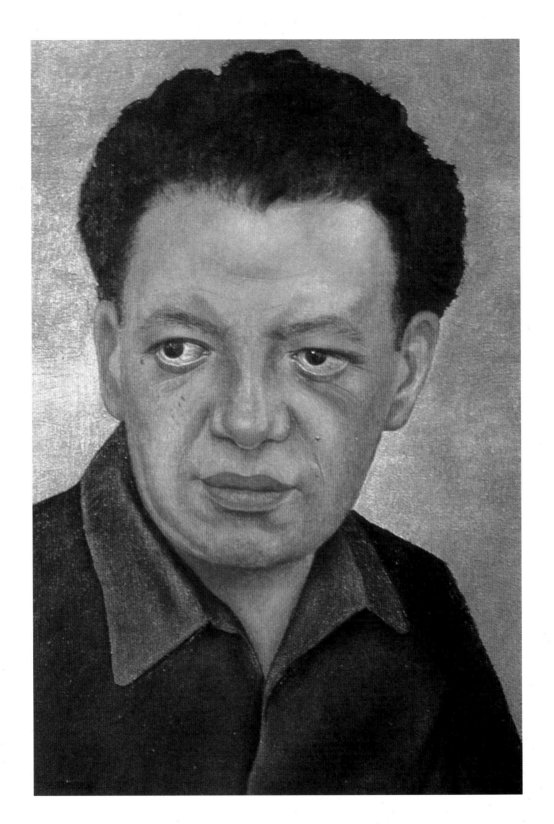

16. *Portrait of Diego
 Rivera*, 1937. Oil on
 canvas, 46 x 32 cm.
 Jacques and Natasha
 Gelman Collection,
 Mexico City.

17. *Self-Portrait with
 Necklace*, 1933.
 Oil on metal,
 34.5 x 29.5 cm.
 Collection Jacques
 and Natasha Gelman,
 Mexico City.

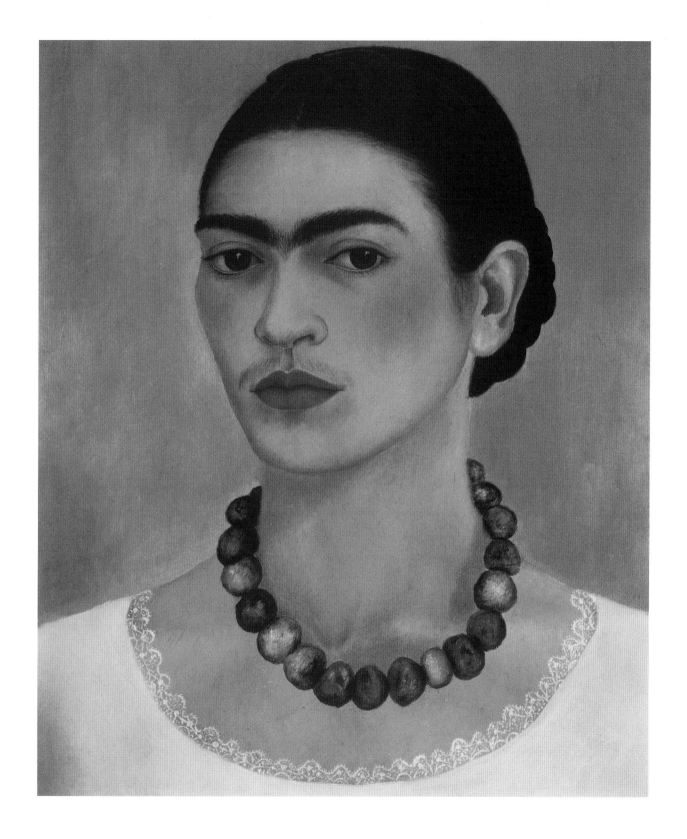

Diego, with the check in his pocket, enjoyed the flap right up until he received a phone call from Chicago canceling the *Forge and Foundry* mural. The Windy City's merchant princes and hog butchers wanted nothing to do with any hint of rabble-rousing or mutterings among the Depression-pinched working class.

In public, Frida spoke to the press:

> *"The Rockefellers knew quite well the murals were to depict the revolutionary point of view – that they were going to be revolutionary paintings...They seemed very nice and understanding about it and always very interested, especially Mrs. Rockefeller..."*

In her private letters and among close friends, she condemned the "sullen" American *cabrones* (bastards) and their hypocritical posturing. But despite the fist-shaking over his work, Diego liked America and the American bohemians and intellectuals who championed his painting and iconoclastic spirit. He also liked what his idolatry purchased in a society that could afford him despite the crushing Depression. He did not want to go back to Mexico.

Frida thought of nothing else. He had gone through their money and they were broke so the Riveras accepted boat tickets from their friends and departed with empty pockets on December 20, 1933, on the *Oriente* via Cuba to Vera Cruz.

Considering their relationship was in tatters, they both appreciated having their own spaces. She plunged into a spate of decorating. Through 1934, the studio went virtually unused except to finish her painting, *My Dress Hangs There* (p. 23), begun in New York.

In the big house, Diego must still have been feeling the disappointment of losing his American mural commissions. Prior to returning to his murals at the National Palace in Mexico City, he began making sketches of Cristina Kahlo, Frida's younger sister. The two sisters had always been close; Cristina was as soft, pliable, feminine and delicate as Frida was assertive and aggressive around men and her pals. Cristina had wed, but her husband had abandoned her and their two children. The two women complemented each other, but Cristina became Diego's favorite model, her Rubenesque nude body appearing in the hall of honor in the Secretariat of Health as the figures "Knowledge" and "Life". Not too long after arriving back in Mexico, Rivera began – or possibly intensified – a destructive affair with Cristina.

Frida knew the signs that Diego was once again involved with someone else, but when the "someone" turned out to be Cristina, Frida was at first crushed and then enraged. She had been betrayed by the two people closest to her.

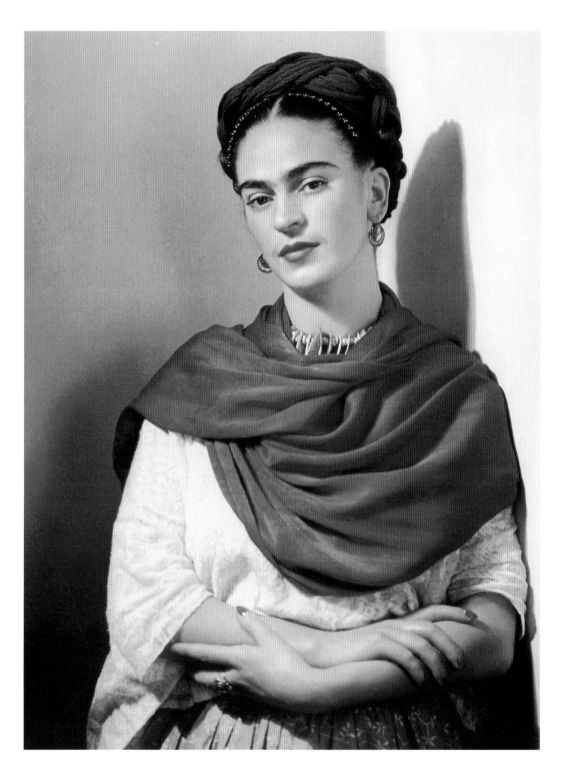

18. Frida Kahlo, 1938-39.
Photography by
Nickolas Muray.
International Museum
of Photography at
George Eastman
House, Rochester
(New York).

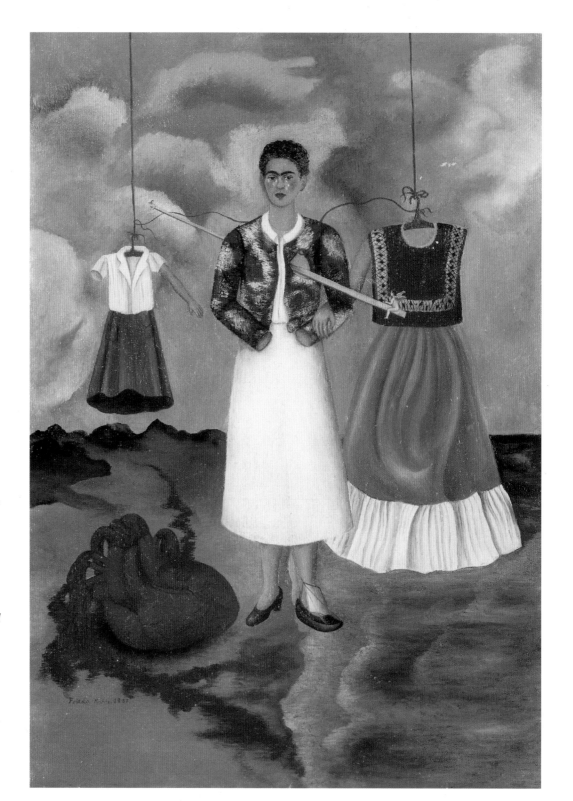

19. *Memory* or *The Heart*,
 1937. Oil on metal,
 40 x 28 cm.
 Private collection,
 New York.

20. *Self-Portrait dedicated
 to Leon Trotsky* or
 Between the Curtains,
 1937. Oil on canvas,
 87 x 70 cm. National
 Museum of Women in
 the Arts, donation by
 Clare Boothe Luce,
 Washington D.C.

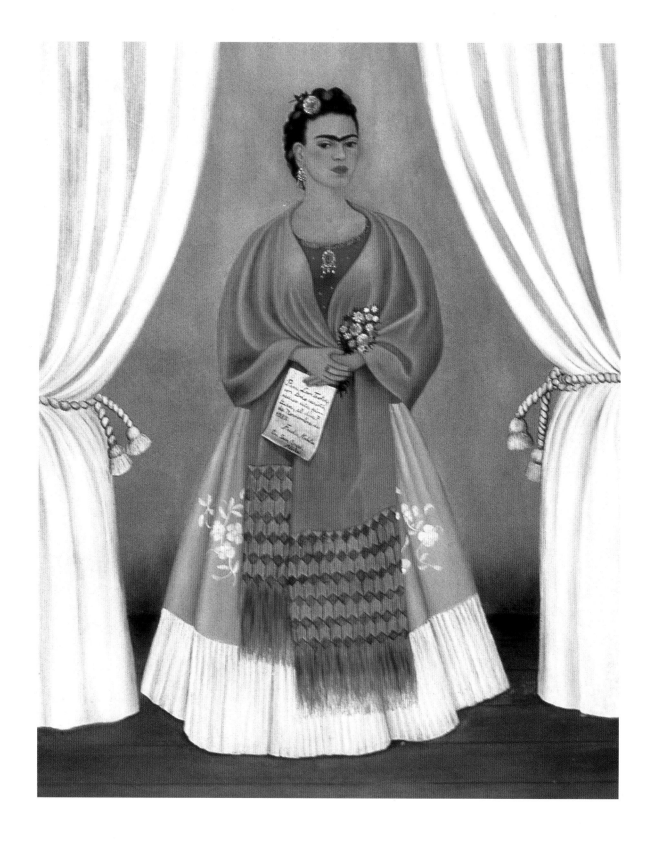

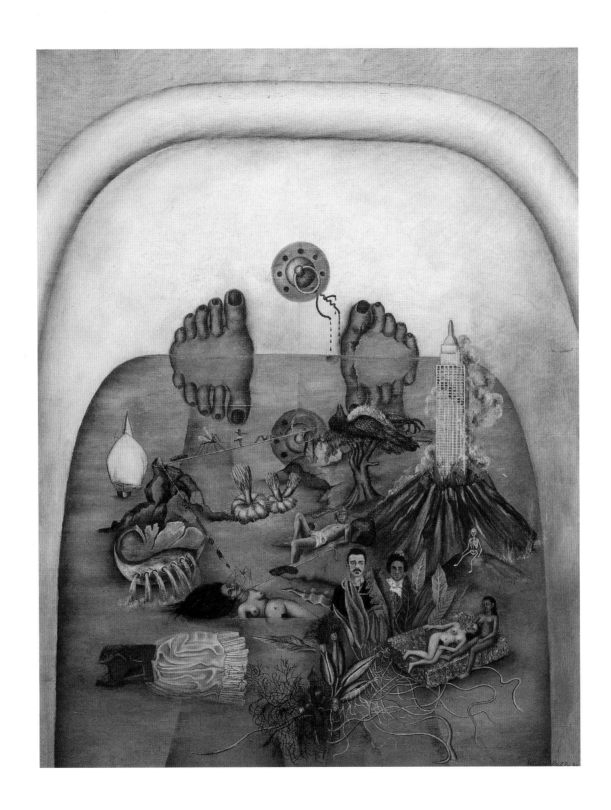

In a fit of anger, she chopped off her long hair. About this same time, in 1934, her health took a downward spiral. Severe pains sent her into the hospital for an appendectomy, and in the third month of yet another unwanted pregnancy, she had an abortion. Lesions opened up in her right foot and became infected.

Throughout her writings to confidants and in her diary, Frida continually defended Diego's petulant moods, his affairs, his depressions and small cruelties to her. She rationalized them as part of his nature. To his considerable discredit, Diego did not break off the affair with Cristina once Frida discovered them. He went on to paint a rather glamorous portrait of the younger sister with her two children in the National Palace mural, partially obscuring a dowdy image of Frida.

All this emotional strife resulted in little creative output from the devastated Frida. But in 1935, the accumulated pain and suffering produced the most horrific of her *retablo*-style paintings on metal. She painted a murder and called it, *A Few Small Nips* (p. 21).

A slaughtered female corpse lies on a bloody bed. Stab wounds are evident all over her contorted nude body. On one leg she wears a black shoe, a stocking and a colorful garter rucked down to her ankle. Above her stands her smirking murderer, still holding his blood-clotted knife. A banner floats above them, carried by a white and a black dove of good and evil.

It reads, "A Few Small Nips." This murder actually took place and was in the newspaper headlines when Frida painted this gore besotted abattoir, letting the blood wash down across the frame. Those were the uncaring words of the murderer, a likely stand-in for Diego Rivera. Once again, she laid bare her emotions with allegory and in doing so helped flush out some of the anguish.

She seemed bent on divesting herself of her previous life, expunging her ties to Rivera, changing her appearance and continuing her painting. She packed up and moved from the Bauhaus blue house to Mexico City, setting up house at 432 Avenida Insurgentes in a small but well appointed apartment. The year became devoted to establishing her new persona, hooking up with old friends and shedding all the bad feelings stored up from her long time away from Mexico. As with most of Frida Kahlo's short life, she was at odds and cross-purposes with herself. In her work, she disliked the *Americanos*, but could not wait to apply what had been made available to her in their country. In her evolving personal life, for all her posturing about the randy Rivera's duplicity, she saw him almost every day.

And he sought her out as well. On July 23, 1935, following their council, Frida wrote to Diego:

21. *What the Water Gave Me*, 1938. Oil on canvas, 91 x 70.5 cm. Collection Isidore Ducasse, France.

"...all these letters, liaisons with petticoats, lady teachers of 'English', gypsy models, assistants with 'good intentions', 'plenipotentiary emissaries from distant places', only represent flirtations, and that at bottom you and I love each other dearly and thus go through adventures without number, beatings on doors, imprecations, insults, international claims – yet we will always love each other."

It appeared that Frida and Diego had to suffer this nadir of their relationship in order to clear the air once and for all concerning their agreement of "mutual independence." There would be more crises, but with this understanding they could, at least, get on with their work. However, she used up the rest of 1935, exercising that "mutual independence" in a number of lesbian and gentlemen affairs. Diego waved off her affairs with women, but even a "mutually independent" Mexican male drew the line at sharing his wife with paramours.

During the warm days of Mexican summer, Frida slipped out of her apartment for rendezvous with men of her choosing. The year 1935 ended with very little painting and much soul searching. A single self portrait was produced showing Frida gazing at us from beneath a boyish mop of short curly hair. What happened next was alcoholism, still more surgery and Leon Trotsky. During and after *L'affaire Diego* – her consumption rose precipitously and she began frequenting *cantinas* in Mexico City and *peluquerias* in near-by villages.

Her reoccurring bad health forced Frida into the American Cowdray Hospital in Mexico City for another bout of surgery. Though it seems difficult to accept considering her active and strenuous lifestyle, Frida Kahlo suffered from daily pain and fatigue.

She had begun to paint again, had established some equilibrium in her relationships with Diego and her sister and looked forward to a period of stability in her congenial, Bohemian lifestyle. And then her life was hurled into emotional chaos. After being battered about by trumped-up charges of counter-revolutionary activities, Trotsky was kicked out of Russia in 1929.

Trotsky and his wife lived off and on at *La Casa Azul* for two years as the aging revolutionary wrote a continuing stream of anti-Stalinist tracts for publication around the world. His old-world manners, admonitions against her smoking and excess drink plus Diego's unswerving devotion to the man made him a perfect target for Frida's considerable powers of seduction and continuing need to give Diego a few more "nips" for his affair with Cristina.

22. *Self-Portrait "The Frame"*, ca. 1938. Oil on aluminium and glass, 29 x 22 cm. National Museum of Modern Art, Centre Georges-Pompidou, Paris.

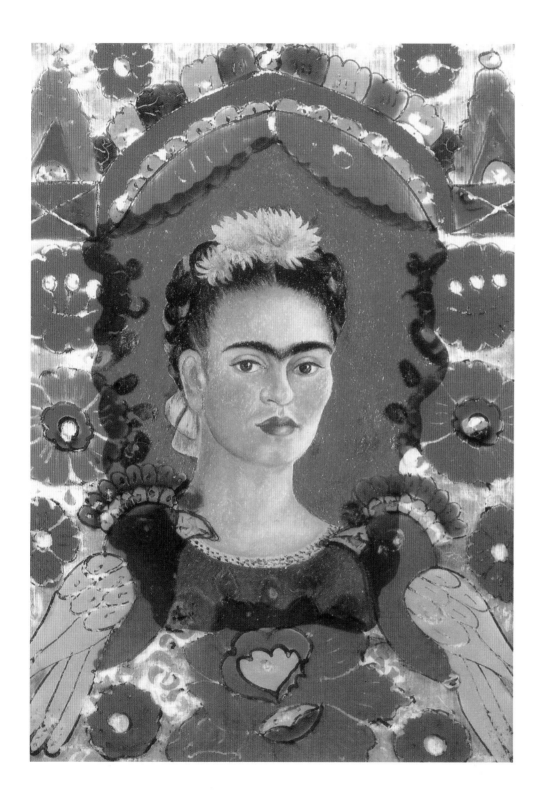

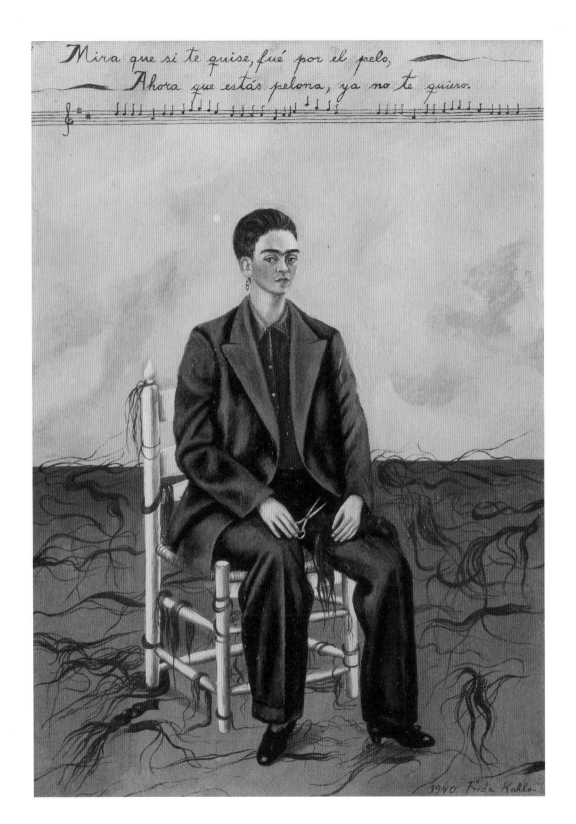

23. *Self-Portrait with
Cropped Hair*, 1940.
Oil on canvas,
40 x 28 cm.
Museum of Modern
Art, New York,
donation by Edgar
Kaufman Jr.

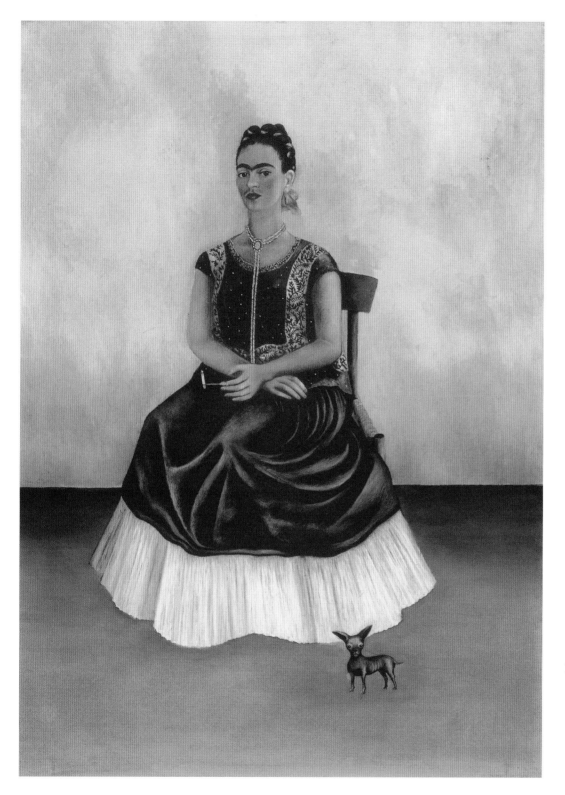

24. *Self-Portrait with*
 Iztcuintli Dog,
 ca. 1938.
 Oil on canvas,
 71 x 52 cm.
 Private collection, USA.

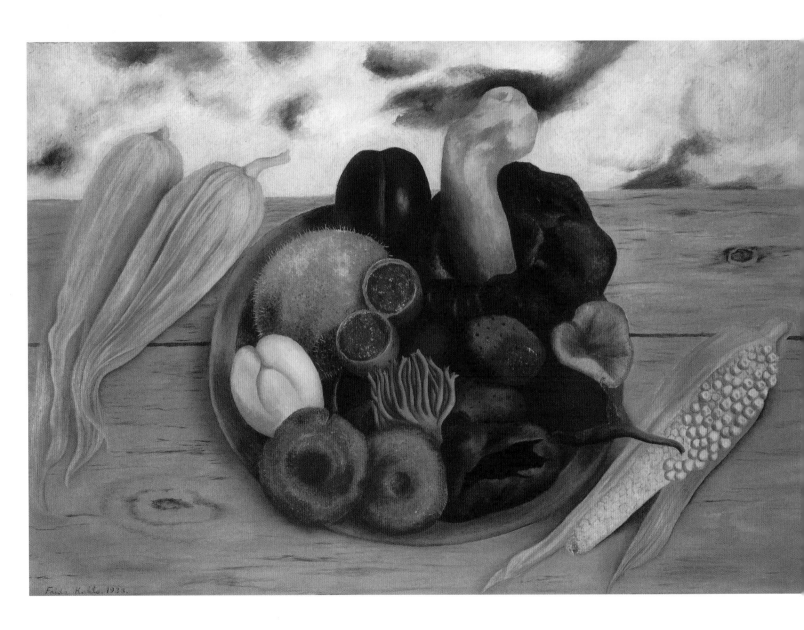

She turned up the heat, speaking to Trotsky in English, a language unfamiliar to Trotsky's wife. She made no secret of her desires in person, and Frida's paintings in 1937 reflected her new confidence and purpose.

The volume of her work increased as did the variety of her subject matter. She also painted her only formal portrait of Diego Rivera. Though his own work volume had slipped, he tirelessly devoted much of his time to propping up Frida's confidence in her capabilities. Her rendition of his diminished presence is tender and sympathetic. On the other hand, his act of callous infidelity with her sister would never be far from Frida's palette and brushes. Amidst this explosion of art, being feminine was important to Frida as she swept into her affair with Leon Trotsky. Keeping Diego and Natalia in the dark was paramount as the two played their games. Frida's full length portrait, *Between the Curtains* (p. 31), that she dedicated in writing to Trotsky – *"For Leon Trotsky with all love I dedicate this painting on the 7th of November, 1937"* – leaves no doubt about her feelings. The fact that she is dressed in her finest *Tehuana* gown with an intricately woven salmon-colored *reboso* across her shoulders, gives additional weight to the importance of this gift.

At the insistence of his entourage who feared security breeches and also that the affair might cause a scandal, Trotsky and his party left *La Casa Azul* on July 7, moving to a hacienda eighty miles away from Mexico City. In 1940, a GPU assassin, planted in the household of Trotsky's final bunker-like home in Mexico, killed the "father of the revolution" with an ice axe.

If her search for expression as an artist traveled along many paths in 1937, Frida Kahlo's perception of the economic value of her work began to stir over the next three years. If the truth be told, she never became a self-sustaining artist.

With her considerable medical bills, love of shopping for jewelry, knick-knacks and dolls, her elaborate costumes and art supplies, plus her growing alcoholism, Frida would be judged "high maintenance" today.

Frida Kahlo was no dilettante. She was extensively well read in art history and had personally examined works of great artists during her time in the United States. She had to know her work stood on its own merit and was unique in its themes and execution. But old insecurities die hard. She was always cast as the outsider, stared at by the gringos in her Mexican costumes, patronized and condescended to by the press. In person, her shield and armor was the witty, sensuous, mildly vulgar, bisexual party girl she had created and inhabited with apparent relish. Her stoic gazes from photos and her paintings translucently concealed the many psychological hurts and slights she had endured.

25. *Fruits of the Earth*, 1938.
Oil on masonite, 40.6 x 60 cm.
Collection Banco Nacional de México, Fomento Cultural Banamex, Mexico City.

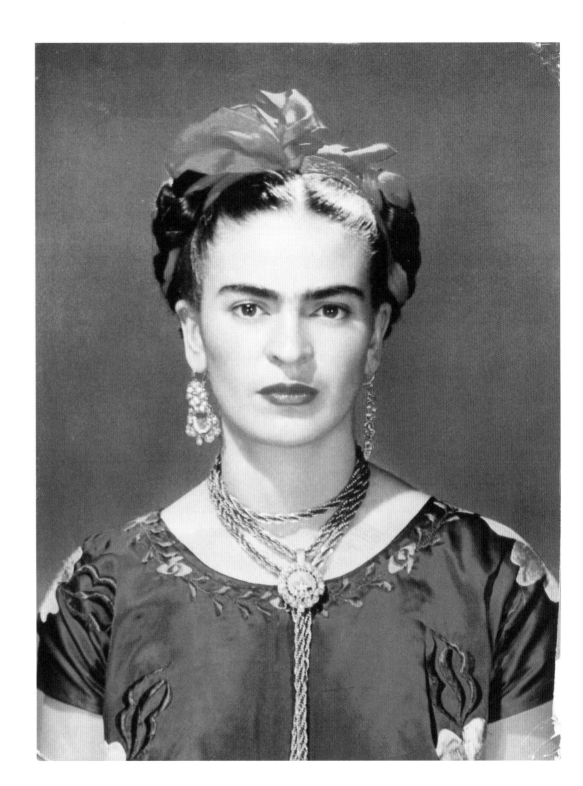

26. Frida Kahlo, ca. 1939.
Photography by
Nickolas Muray.
International Museum
of Photography at
George Eastman
House, Rochester
(New York).

27. *The Two Fridas*, 1939.
Oil on canvas,
173.5 x 173 cm.
Museo de Arte
Moderno,
Mexico City.

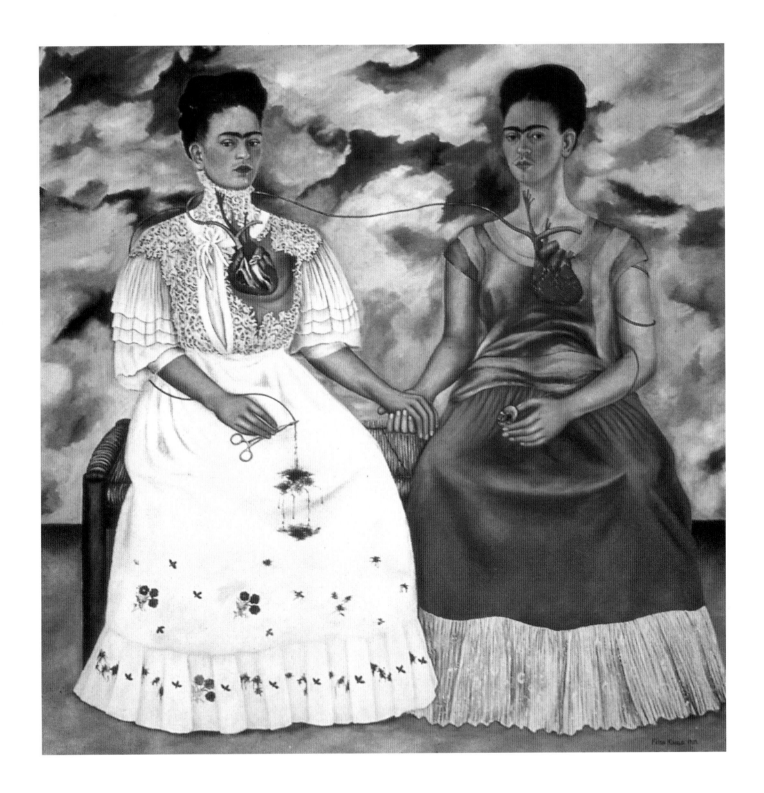

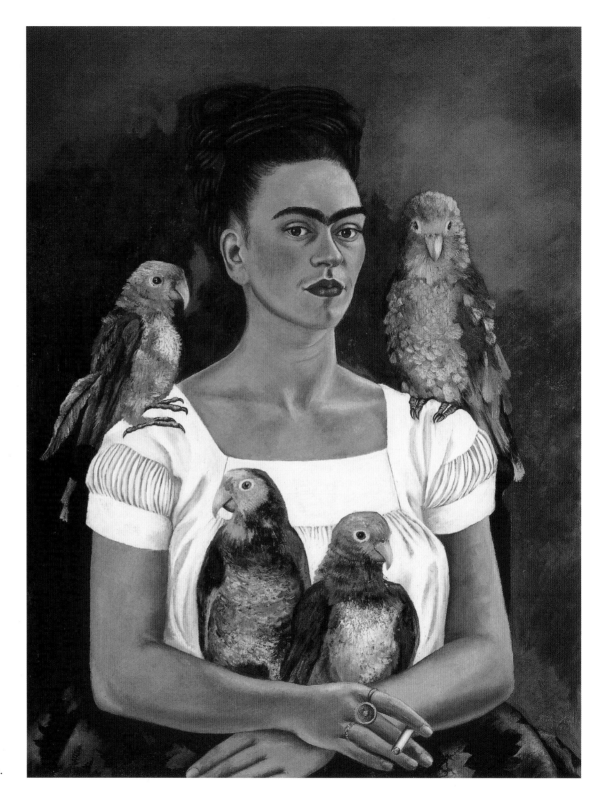

28. *Me and My Parrots*,
 1941. Oil on canvas,
 82 x 62.8 cm.
 Private collection.

29. *Self-Portrait with
 Monkey*, 1940.
 Oil on masonite,
 55.2 x 43.5 cm.
 Private collection, USA.

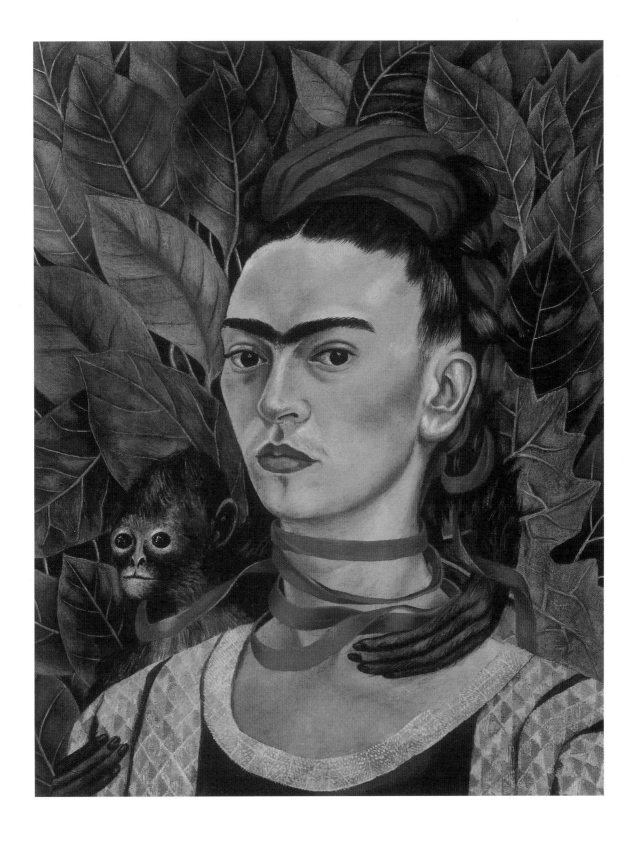

But if she wanted to have the last laugh, there was nothing for it but to place her inner secrets, scars and personal mythology in front of the public inquisition and await the reading of the verdict.

At a group exhibition of Mexican art held in the Social Action Department Gallery of the University of Mexico, she sent *My Grandparents, My Parents and I* (p. 25) and three other "personal" works to the "…small and rotten place." She confessed to Lucienne Bloch, "…I send them there without any enthusiasm, four or five people said they were swell…"

She was completely unprepared for the letter that arrived a short time after the show closed. Manhattan gallery owner Julien Levy had been approached by someone who had seen the University exhibition. Levy asked if she would consent to an exhibit of her paintings in his gallery on East 55th Street. She sent him a few photos of her paintings. Levy answered with another, even more enthusiastic letter. Could she send 30 works by October? Yes, she could and began looking at her works in a new way, as her personal creations hanging on walls in a gallery in New York City.

Spurred on by the New York show's promise, Frida's output soared. In 1938, she painted *What the Water Gave Me* (p. 32), *Four Inhabitants of Mexico City*, *Girl with Death Mask* and a series of still lifes. Self portraits for that period included the wildly colorful *Framed Self-Portrait* (*The Frame*) (p. 35) and an almost monochromatic *Escuincle Dog with Me*.

This series of paintings demonstrates the wide range of her selected subject matter, palettes, and the storehouse of internal imagery she could call upon. Fortified with letters of introduction from Diego to the high and mighty of New York's art world and an invitation list representing a powerful cross-section of the social set they had cultivated back in 1933, Frida plunged into the scene. She was an immediate sensation. Critics loaded and cocked their pens, but came away charmed and impressed.

Though she moved through the opening night crowd as the star of the show, it was obvious that the ghost of Diego Rivera was both a drawing card and a *raison* for New York to pay homage to his third wife. Regardless, she relished the attention. In particular, she enjoyed her distance from Diego and the unfettered freedom to flirt with men and women of her choice. Her exotic presence, her costumes, and even her bold, scrappy, almost mannish aggression drew companions to her. She reunited with her old flame, Isamu Noguchi and hooked up with handsome fashion photographer Nickolas Muray. In hot pursuit, however, was her sponsor, Julien Levy. He fluttered around her, ever the handsome attentive butterfly. In the end, Levy got his wish when Frida sneaked into his bedroom.

Muray had better luck. He had met Frida in Mexico and helped her with the catalog for her show. The socially prominent photographer was handsome and self-confidant.

30. *The Dream* or *The Bed*, 1940. Oil on canvas, 74 x 98.5 cm. Collection Isidore Ducasse, France.

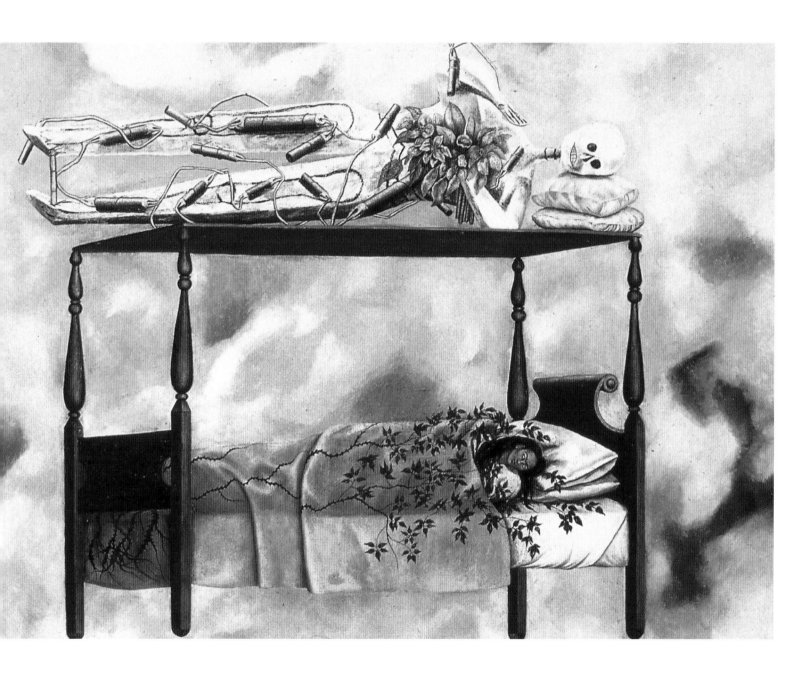

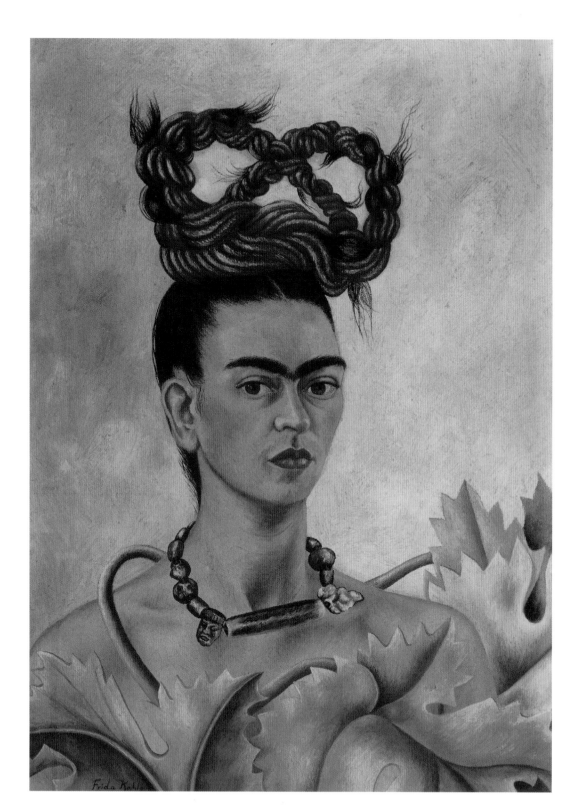

31. *Self-Portrait with
 Braid*, 1941.
 Oil on masonite,
 51 x 38.5 cm.
 Collection Jacques
 and Natasha Gelman,
 Mexico City.

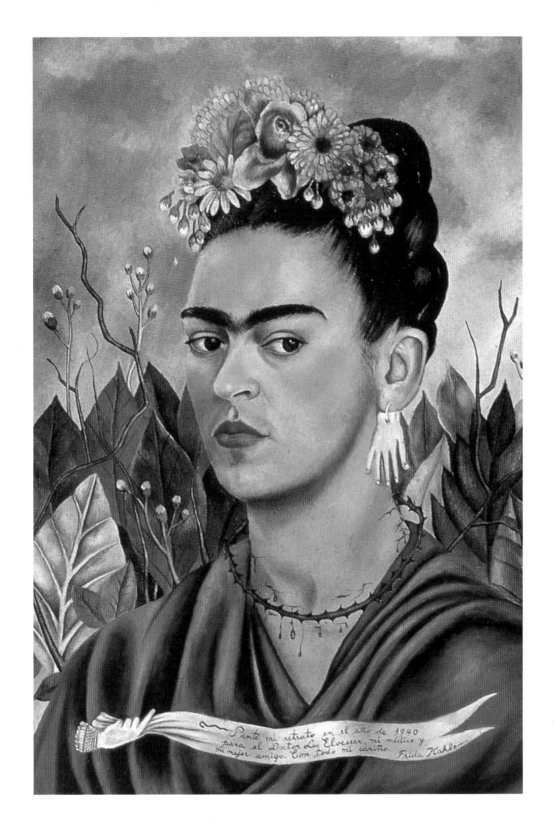

32. *Self-Portrait dedicated
 to Dr. Eloesser*, 1940.
 Oil on masonite,
 59.5 x 40 cm.
 Private collection, USA.

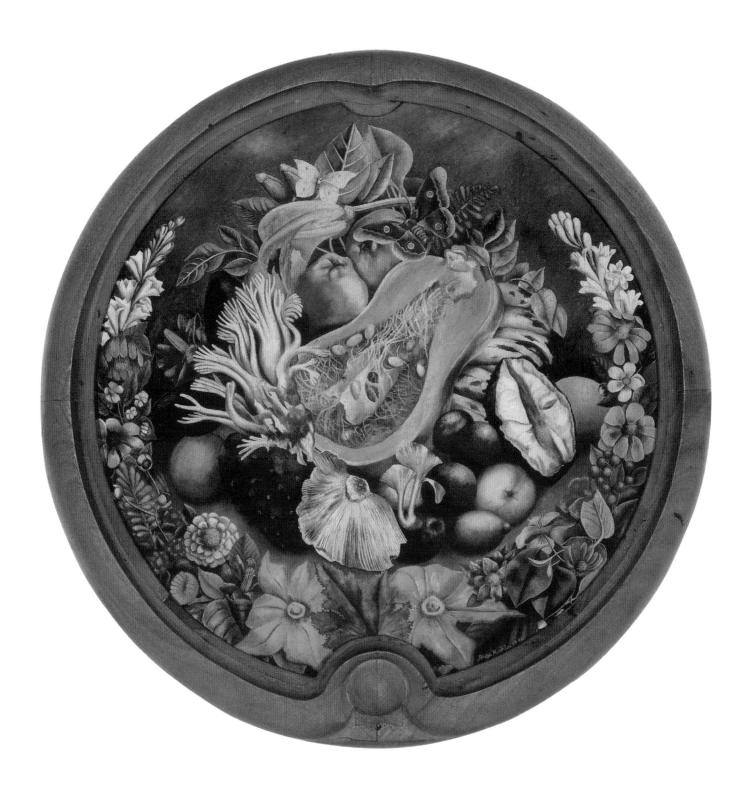

Their affair began in Mexico City, but without gun-toting Diego lumbering about, they caught fire in New York and she fell hard for him.

"– My lover, my sweetest mi Nick – mi vida – mi nino, te adoro."

Art lovers purchased about half the paintings that were offered for sale – which is a good first outing – and Frida managed to snag a few commissions.

By the time the show closed, Frida was exhausted. Her health had failed near the end of her stay and she spent considerable time visiting doctors to deal with her back, spine, foot, and leg problems. But she returned to Mexico looking forward to her next *sortie*, this time into the bastion of the Europeans, a show of her work by Andre Breton in Paris.

As a show organizer, Breton turned out to be a disaster. Frida found her paintings still held unclaimed in customs and no gallery had been selected for the show. She was furious. To her benefit, Frida received her closest exposure to the Surrealists since being admitted to their number. Max Ernst, Duchamps, Man Ray and Breton all welcomed her, and she did her best to be no less outrageous than them. She also managed a stroke of recognition that had been withheld from her famous husband. The Louvre purchased *The Frame* that today is part of the George Pompidou Centre collection. Unfortunately, *The Frame* was her only sale.

By March, 1939, Frida was sated with Parisian art life and packed up for a trip to New York to spend some time with Nick Muray. As with Noguchi, separation had cooled Muray's love, and Frida discovered he was engaged to be married to another woman. The destruction of this romance hurt Frida deeply and pointed out to her how trapped she was in her relationship with Rivera. Her life had opened up with many possibilities following her trips abroad and exposure to a new independence. A Noguchi or a Muray might have opened even more doors to her independent life, but she had thrown in her lot with Rivera at such an early age, they were seen as two sides of the same coin.

She returned to Mexico in May, 1939, and as her relationship with Rivera deteriorated, she poured her emotions and frustration into painting. The men in her life had done Frida a great disservice from which she would never completely recover. She needed a final act that was both symbolic and real.

Sexual relations had ended. Civility had ended. The gayety and adventures had ended. All that remained were obligations Diego and Frida accepted as parts of an unspoken agreement, the trickle of a relationship that no legality could sever. It is possible that Diego had heard of Frida's affair with Trotsky. Her reasons were obvious and humiliating. They were formally divorced on November 6, 1939.

33. *Still Life*, 1942. Oil on copper, ca. 63 cm in diameter. Museo Frida Kahlo, Mexico City.

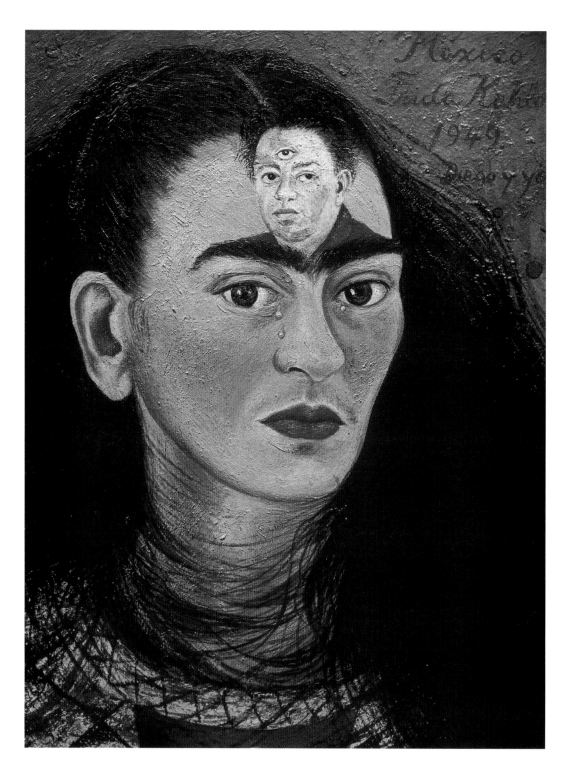

34. *Diego and I*, 1949.
 Oil on canvas,
 mounted on board
 28 x 22 cm.
 Private collection.

35. *Thinking about Death*,
 1943. Oil on canvas,
 mounted on masonite,
 44.5 x 36.3 cm.
 Museo Dolores
 Olmedo Patiño,
 Mexico City.

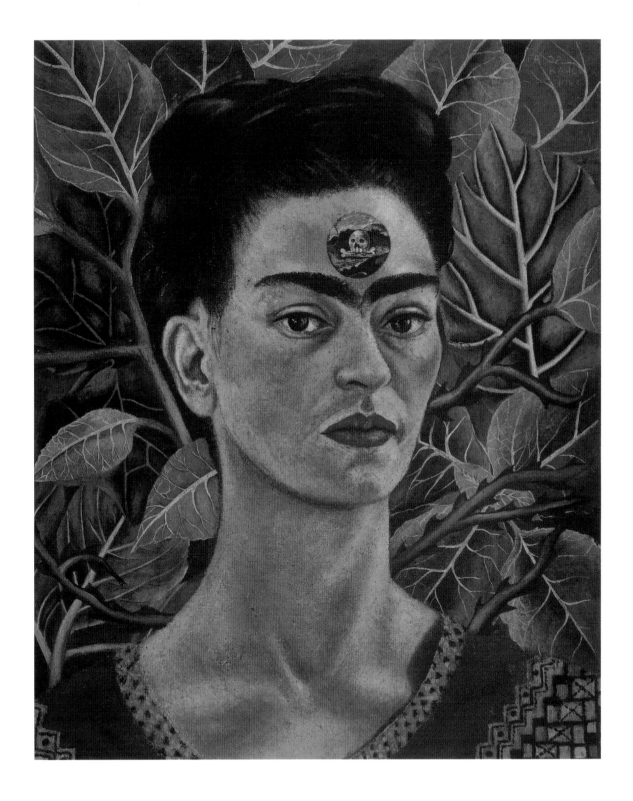

The six-foot square *The Two Fridas*, that she painted at this moment, would become her signature masterpiece. A mirror had long played a central role in her paintings, at first from necessity due to her bed-ridden state. Later, the mirror became a reflection of reality that could be manipulated and translated into a fantasy vision of her very personal *vérité*. In *The Two Fridas* (p. 41), the mirror duality becomes a schizophrenic visualization of Frida's personal dilemma: the European woman (Frida) in white with lace and appliqués befitting a chaste Catholic girl and the *Tehuana* woman of darker skin and colorful costume, the earthy peasant persona encouraged by Diego Rivera.

The 1940s came at Frida Kahlo in a rush of contradictions. Legally, she had shed her ties with Diego Rivera, but financially her life was bound to him through a complex banking arrangement where her expenses were paid from sales of his work. With her life in this turmoil of contradictions, she doggedly pressed forward with her art. Frida imagined her self esteem could only survive through the success of her paintings in what remained of the art world outside the distraction of world war.

Once again, Diego intervened in her self-destructive lifestyle and consulted their mutual friend, Dr. Eloesser, in San Francisco. The doctor suggested she come to the States. She had spent three months in a traction device connected to her chin and welcomed the invitation from her old friend. Frida arrived in San Francisco in September, 1940. Eloesser immediately committed her to a rest cure and assorted therapies in St. Luke's Hospital for her exhaustion and alcoholism. He also contacted Diego and explained that the Mexican doctors' grim diagnoses such as tuberculosis of the bones and a need for spinal surgery were false and what she needed was her *Panzon* at her side during her recovery. While he had her under his cure, the doctor was determined to effect a reconciliation between the two artists who were miserable in their self-imposed separation.

"No sex" and "no cash" were two of Frida's stipulations to make the remarriage work. She had no intention of sharing Diego sexually with any other women and she insisted on making her own way financially and paying half of the household expenses. Diego was pleased with the former and maintained the mutually accepted fiction of the latter. December 8, 1940, they were remarried in a civil ceremony.

Her fortunes were once again on the rise. She joined Diego in the International Golden Gate Exhibition where he executed a mural on Treasure Island. They spent Christmas in Mexico with Frida's family and then he returned to complete the mural. While he was gone, Frida reveled in a period of relatively good health, shopping in Coyoacán and Mexico City, sunning herself in the garden, or preparing Diego's room for when he returned.

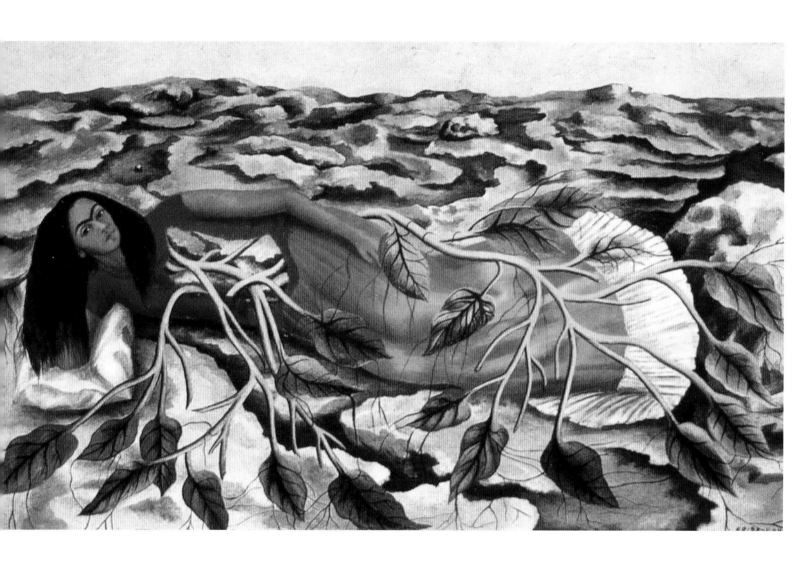

36. *Roots* or *The
Pedregal*, 1943. Oil on
metal, 30.5 x 49.9 cm.
Private collection,
Houston (Texas).

37. *Self-Portrait as a Tehuana* or *Diego on my Mind*, 1943. Oil on masonite, 76 x 61 cm. Collection Jacques and Natasha Gelman, Mexico City.

38. *Portrait of Doña Rosita Morillo*, 1944. Oil on canvas, mounted on masonite, 76 x 60.5 cm. Museo Dolores Olmedo Patiño, Mexico City.

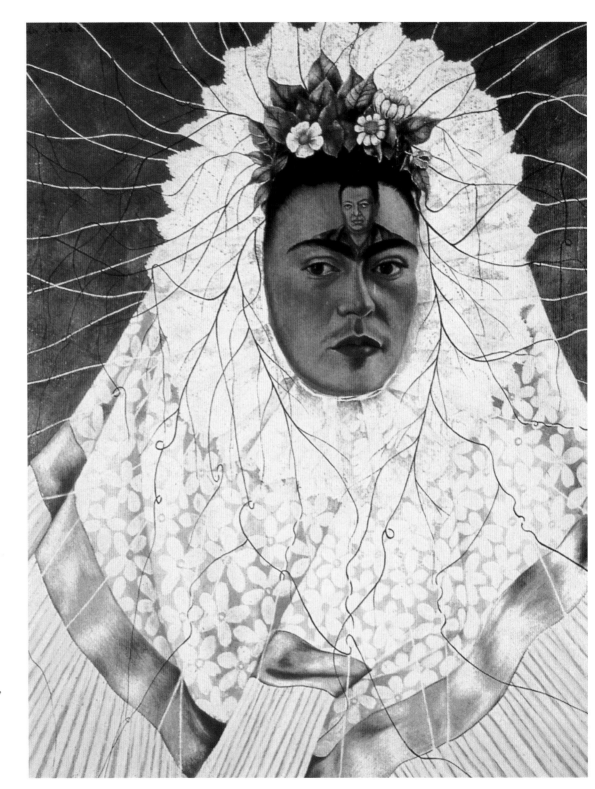

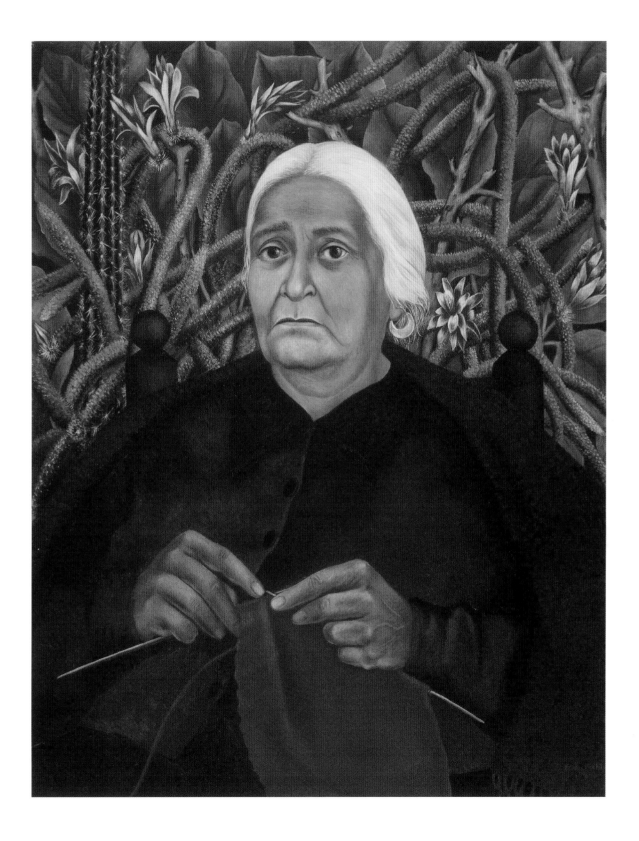

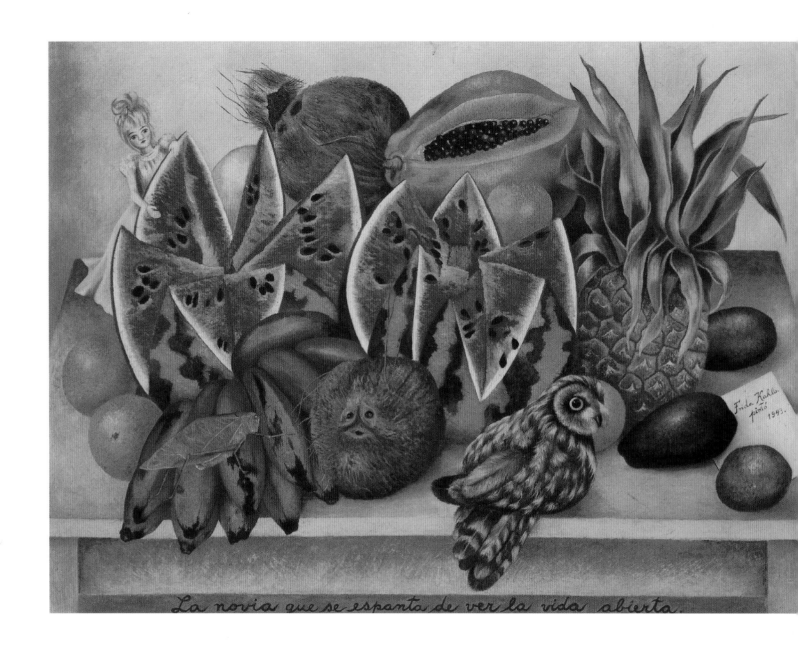

La novia que se espanta de ver la vida abierta.

39. *The Bride Frightened
at Seeing Life
Opened*, 1943. Oil on
canvas, 63 x 81.5 cm.
Collection Jacques
and Natasha Gelman,
Mexico City.

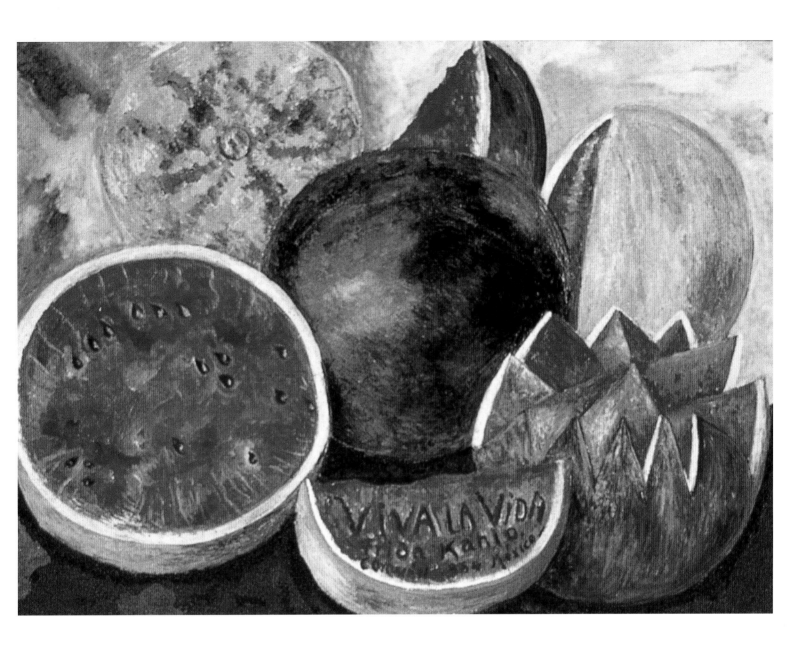

40. *Still Life: Viva la Vida*
 (*Long live Life*), ca.
 1951-54. Oil and earth
 on masonite,
 52 x 72 cm.
 Museo Frida Kahlo,
 Mexico City.

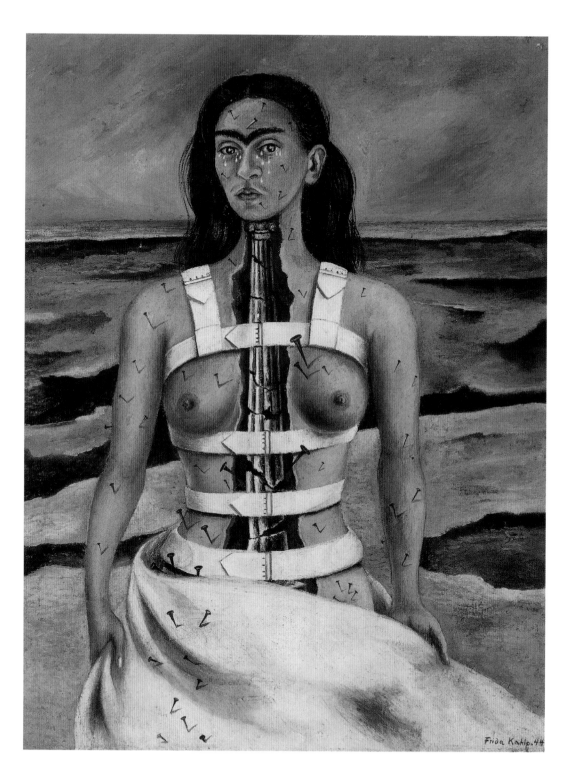

41. *The Broken Column*, 1944. Oil on canvas, mounted on masonite, 40 x 30.7 cm. Museo Dolores Olmedo Patiño, Mexico City.

Just as her life had once again settled into a comfortable pattern, the summer heat brought with it a further deterioration in her health, weakness and loss of weight. In July, her father, Guillermo, died. Frida's troop of doctors marched back into her life with brand new plaster corsets for her back, X-rays, hormone injections, cures for the fungus that infected her right hand, pills and injections for angina and *la grippe*. She smoked too much and still drank a few too many *copitas* with meals.

She began teaching in 1943 at the experimental School of Painting and Sculpture on Esmeralda Street in the Guerrero District. Like the National Preparatory School she had attended, this *high school secundaria* offered free courses in painting and drawing as well as French, art history, Mexican Art and culture. Like her own self-designed Bohemian education, she took her students beyond the walls of the school and into the streets to observe and experience life for their work. Her health forced the painting and drawing classes to be held in *La Casa Azul*. She loved this work and was, in turn, loved by her students, who came to be called, *Los Fridos*. To keep generating revenue, Frida accepted portrait commissions from local politicians, friends, and her patrons.

The self-portraits persisted as the body cannibalized itself toward eventual destruction, and her mind endured the metamorphosis from youthful anticipation to the dawning realization that the fantasy of a life without daily stabs of physical pain was a false hope. In effect, Frida created her own exhibition of self images that, over time, produced a visual documentary displaying the day by day corruption of her physical and mental world from behind a mask that never complained or cried. Every day, she added a brush stroke to her own impassive monument.

The downward spiral of her health kept a gaggle of doctors busy. The pain in her right foot had become virtually constant and the need for permanent relief, not drugged respite that impaired her ability to paint, became a constant quest. A Doctor Alejandro Zimbron decided a steel corset would ease the pain and give her back support. With it in place, she began fainting and lost 13 pounds in six months. The pain was still there.

Zimbron added spinal injections to the treatment. She experienced excruciating headaches. A year later, in 1945, Doctor Ramiriz Moreno diagnosed syphilis and began blood transfusions. The pain continued and syphilis was never proved. Zimbron tried again with a traction device that hung her face-down from the ceiling to relieve stress on her spine. With sandbags laced to her feet, she hung there for three months, painting for at least an hour every day. While she dangled, other doctors conceived a variety of corsets made with plaster, steel, a combination of plaster and steel, and leather. One corset applied by an inexperienced doctor did not cure properly and almost suffocated her before being frantically cut away.

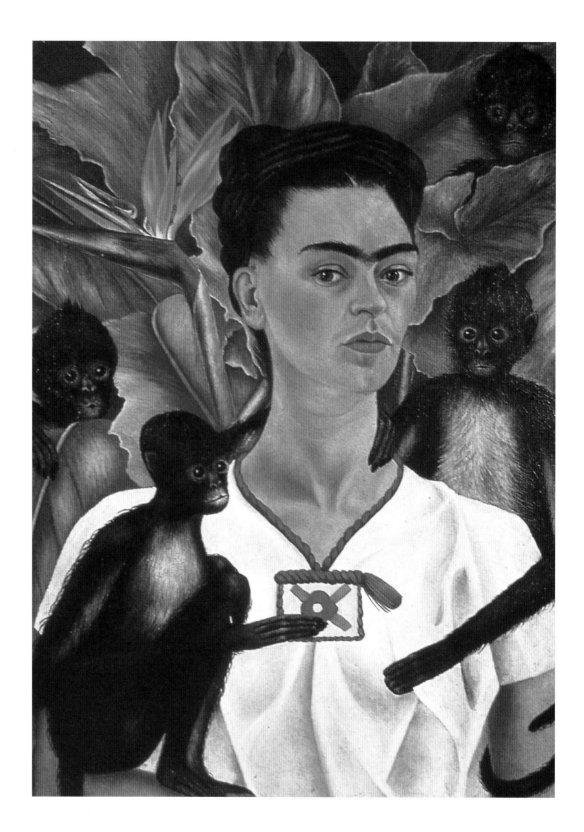

42. *Self-Portrait with
 Monkey*, 1945.
 Oil on masonite,
 60 x 42,5 cm.
 Museo Dolores
 Olmedo Patiño,
 Mexico City.

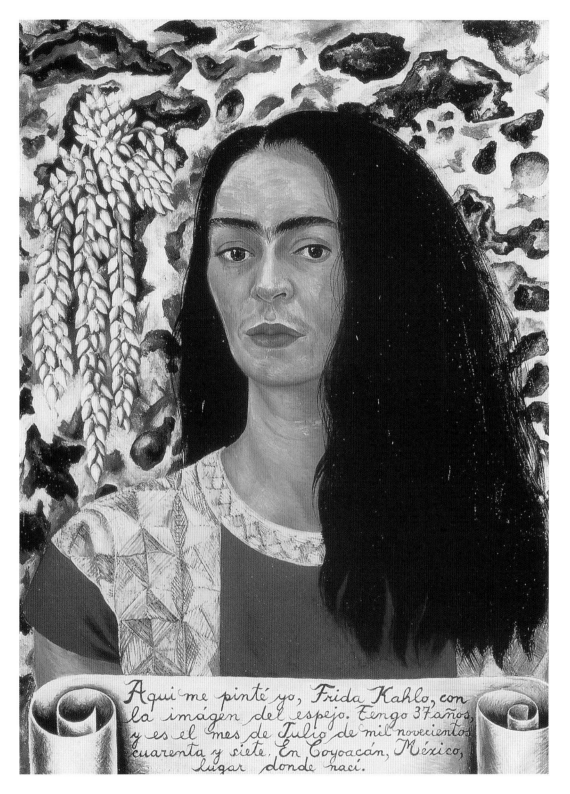

Aqui me pinté yo, Frida Kahlo, con
la imágen del espejo. Tengo 37 años,
y es el mes de Julio de mil novecientos
cuarenta y siete. En Coyoacán, México,
lugar donde nací.

43. *Self-Portrait with Hair Down*, 1947.
Oil on hard fibre,
61 x 45 cm.
Private collection.

She had 28 corsets lashed or slathered onto her torso during her last ten years. The toes of her right foot contracted gangrene and required amputation, although they dropped off of their own accord. Most of these "cures" only exacerbated the pain and deepened her addiction to narcotics, which did not go well with the bottle of brandy she downed almost every day.

In 1946, she traveled to New York for major surgery. Doctor Philip Wilson, a back specialist, had suggested fusing certain of her vertebrae and fixing them in place with a steel rod.

"Anguish and pain, pleasure and death," Frida writes, *"are no more than a process."*

In 1950 a bone graft from a piece of her pelvis followed the failed fusion and was equally unsuccessful. And by now, a previous fungus growth appeared once again on her hand. An abscess was discovered beneath one of her corsets and a surgical wound that had also not healed properly. She spent that year in bed. For much of her stay, Diego took a room next to hers and did what he could to keep her spirits up.

By now, Diego Rivera was part of an aging mythos, the Mexican mural movement that began in 1922. Though he remained popular, his legend appeared in the past tense as Frida Kahlo's was in ascendancy. Her work had appeared in a number of group shows around the world and earned decent prices from a growing number of collectors. Diego took great pride in her success and took every opportunity to show her off and praise her talent. That did not stop him from having affairs, or stop her from abusing doctors' orders.

By 1951, she emerged from her year of hospitalization to be confined to a wheel chair. By this time, she must have sensed that there was not much time left to her. As with many who face death, she sought a return to her only religion. Frida rejoined the Communist Party. Even in her wheel chair, she could still offer up her rally voice singing the *Internationale* and raise her fist in solidarity with her comrades. Her loyalty to Mexico was finally honored in April, 1953, when Frida's friend, Dolores Alvarez Bravo, devoted her *Galleria de Artes Contemporaneo* to a one-woman show of Frida Kahlo's work. This was the only such show accorded Frida in Mexico in her lifetime. At the time of the show's opening, her body was hacking its way through a bronchitis attack and she was confined to her bed. She and the bed were delivered to the gallery behind an escort of police sirens and tooting horns. There, heavily sedated, she became part of her exhibit, smiling up from her four-poster resting place at well-wishing faces from her past and those silent familiar witnesses looking down from the walls.

44. *Magnolias*, 1945.
 Oil on masonite,
 41 x 57 cm.
 Collection Balbina
 Azcarrago,
 Mexico City.

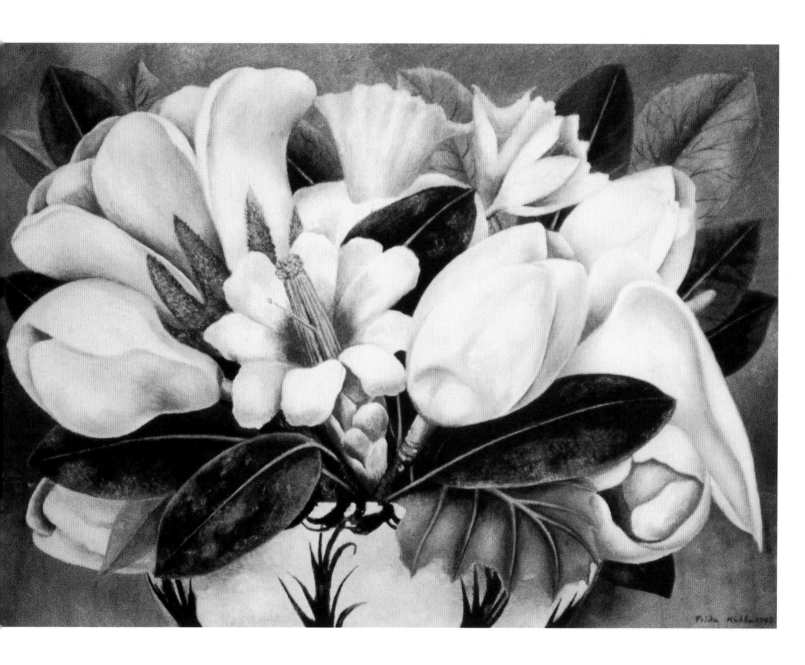

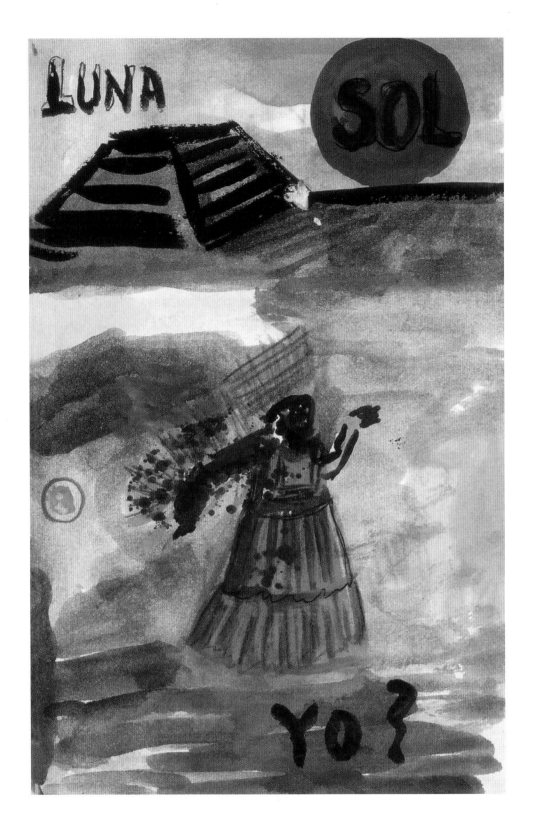

45. Page from her diary (1946-54) showing the artist's personal conflict in *Moon, Sun, I?*.

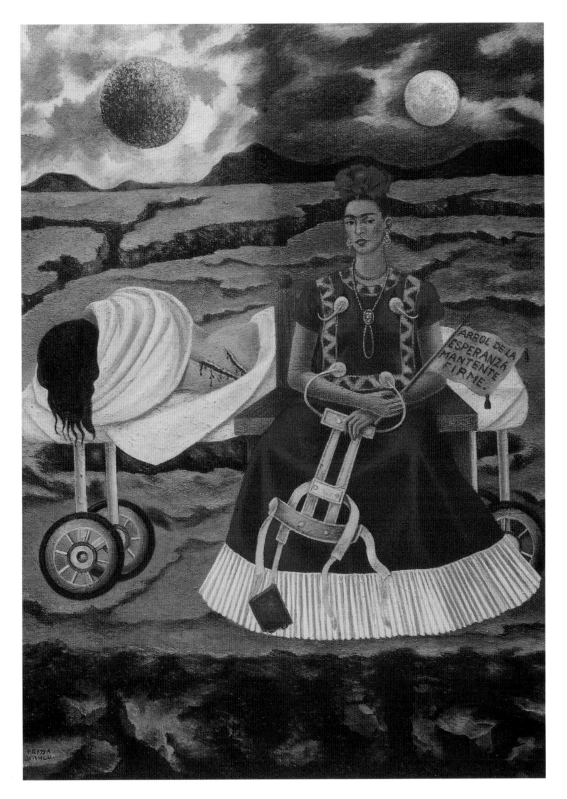

46. *Tree of Hope, Keep Strong*, 1946.
Oil on masonite,
55.9 x 40.6 cm.
Collection Isidore
Ducasse, France.

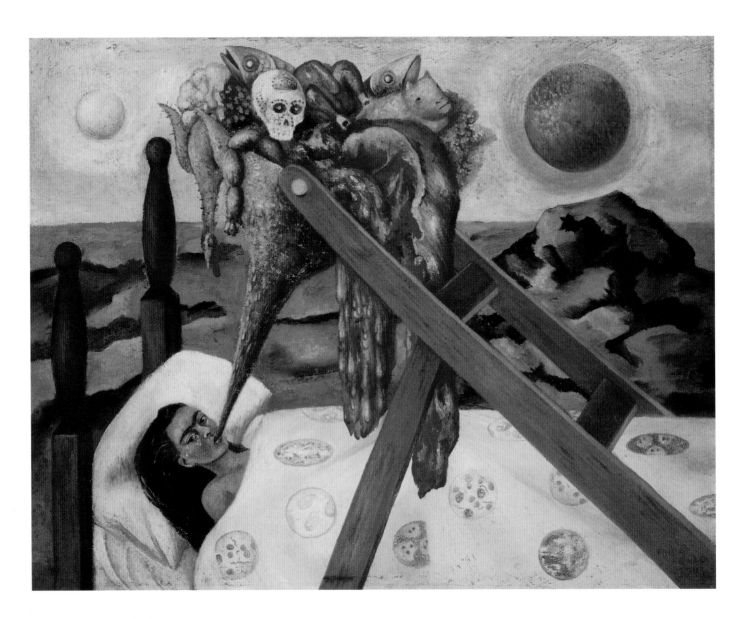

47. *Without Hope*, 1945.
Oil on canvas,
mounted on masonite,
28 x 36 cm.
Museo Dolores
Olmedo Patiño,
Mexico City.

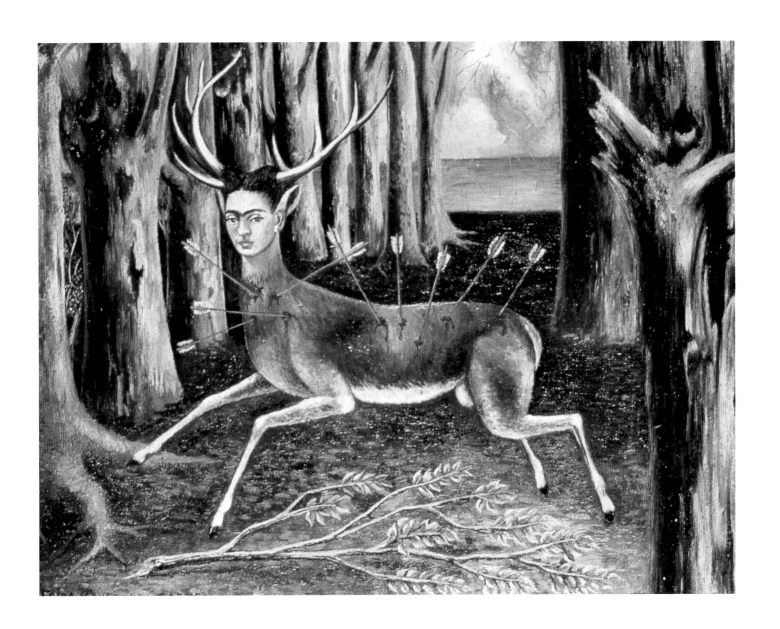

48. *The Wounded Deer*
(*The Little Deer*),
1946. Oil on masonite,
22.4 x 30 cm.
Private collection,
Houston (Texas).

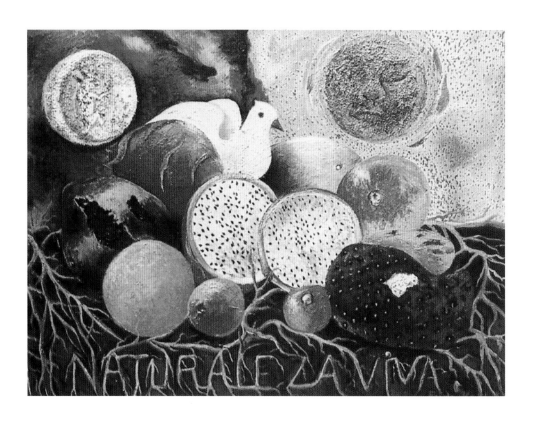

As 1953 drew to a close, her painting continued, though its brushwork had reverted to a more primitive style from her learning years in the 1920s. She seemed to collapse into herself following the amputation of her right leg that had become septic with gangrene. She had kept that leg since her brush with polio at age 13 when it was turned into a withered "cane." The bus accident had broken it in eleven places. She had dragged it with her for more than 30 years, and in all her paintings of that treacherous limb, she had used a mirror reflection and rendered it as her *left* leg. Now, it had been hacked off below the knee. Frida grudgingly accepted a wooden leg, but she was too frail to get much use from the prosthetic. Her addiction to pain killers and reliance on alcohol also made its convenience more hazardous than useful. Despite daily injections that left her back and arms covered with scabs, she managed long periods of lucidity, keeping notes in her diary, and working on an autobiography through 1953. Her final painting titled, *Viva la Vida*, (Long Live Life) (p. 57) depicts a collection of chopped watermelons with those words inscribed into a melon's pulp. She attended a Communist rally on July 2, 1954, shaking her fist and chanting with the crowd. Ten days later, as Diego sat with her holding her hand, she gave him a silver ring celebrating their 25th wedding anniversary 17 days distant. When he questioned the timing of her gift, she said, "…because I sense that I'll be leaving you very soon."

49. *Moving Still Life*, 1952. Oil on canvas. Collection María Félix, Mexico City.

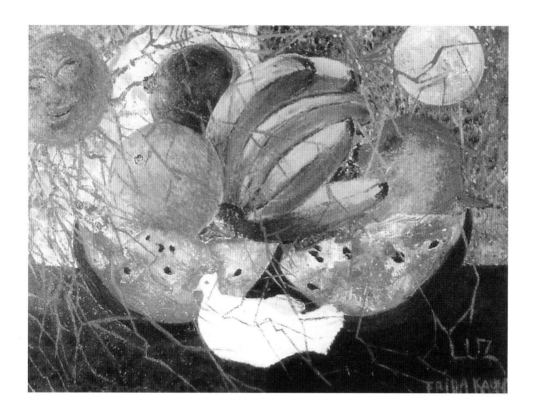

On July 13, 1954, Frida Kahlo died at age 47. In a drawer near her bed was a large cache of Demerol vials, but some of her friends claimed she would never have taken her own life. Others disagreed. The official death certificate cites "pulmonary embolism."

She had chosen cremation. Meticulously dressed in a Tehuana costume and bedecked with her jewelry, Frida's body was driven to the Palace of Fine Arts in Mexico City where more than 600 visitors paid their respects beneath the lobby's towering neoclassical ceiling. A distraught and shaken Diego Rivera sat at her side throughout the visitation. Earlier, in his state of weeping denial, he had her veins cut to make sure she was truly dead. The funeral became a politically charged (a red hammer-and-sickle Communist flag had been draped on her coffin), overwrought, emotional event totally in keeping with her chaotic lifestyle.

In his autobiography, he admitted, *"…Too late now, I realized that the most wonderful part of my life had been my love for Frida."*[2] Diego Rivera died in Mexico City in 1957.

In her 1953 autobiography, Frida wrote:

"Painting completed my life. I lost three children and a series of other things that would have fulfilled my horrible life. My painting took the place of all of this. I think work is the best."

50. *Fruits of Life*, 1953.
 Oil on hard fibre,
 47 x 62 cm.
 Collection Raquel
 M. de Espinosa
 Ulloa, Mexico City.

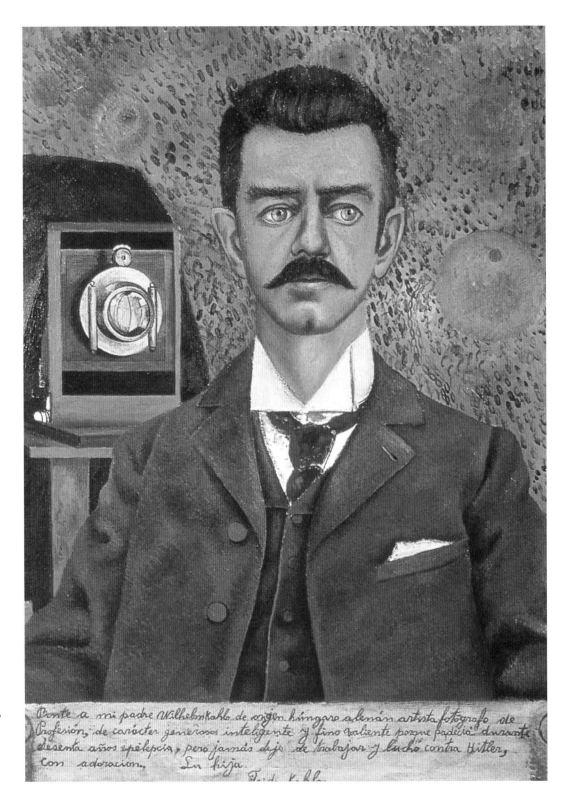

51. *Portrait of My Father*,
 1951. Oil on masonite,
 60.5 x 46.5 cm.
 Museo Frida Kahlo,
 Mexico City.

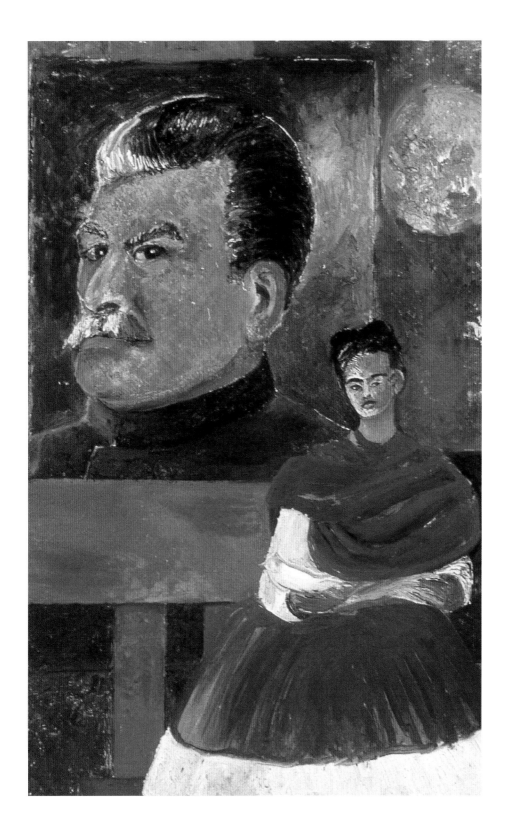

52. *Self-Portrait with Stalin* or *Frida and Stalin*, ca. 1954. Oil on hard fibre, 59 x 39 cm. Museo Frida Kahlo, Mexico City.

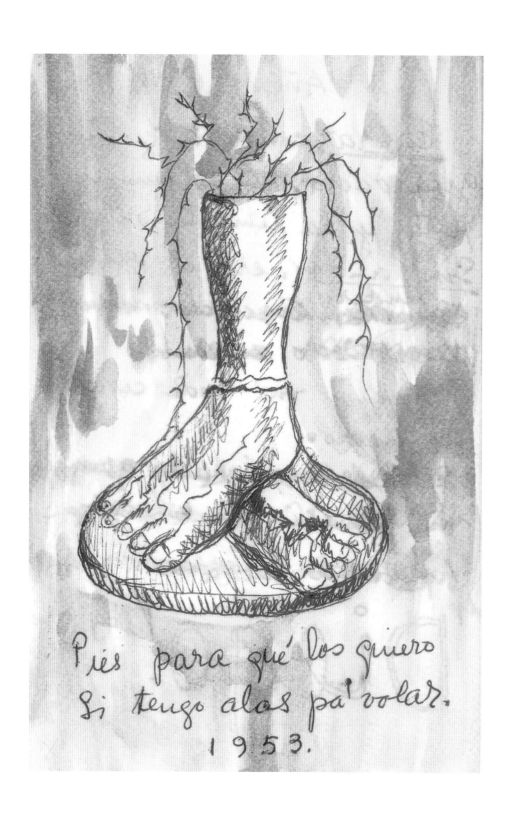

Pies para qué los quiero
Si tengo alas pa' volar.
1953.

53. Diary page, 1953.
The two tortured feet
refer to the pain that
the artist suffered in
her legs and feet
throughout her life.
In 1953, she agreed
to have her foot
amputated.

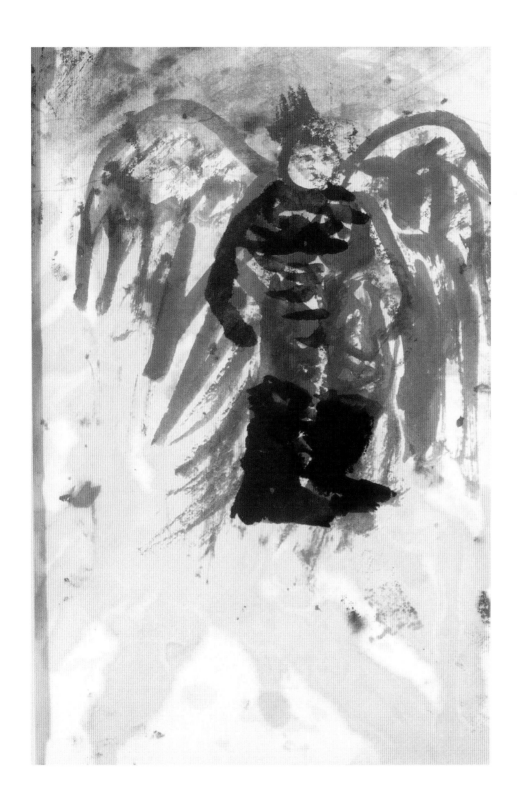

54. The last picture in her
 diary.

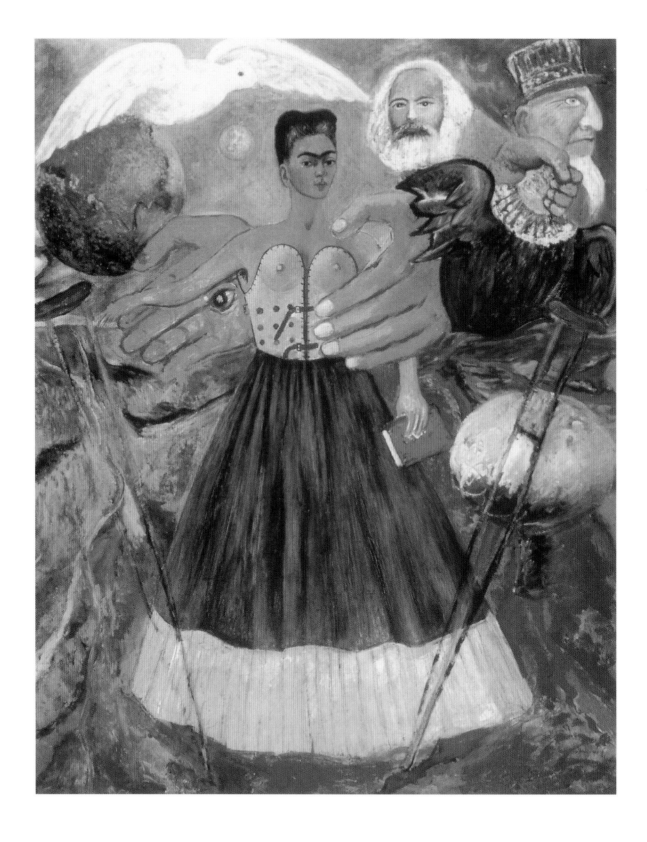

BIOGRAPHY

1907

Magdalena Carmen Frida Kahlo is born July 6, in la Casa Azul in Coyoacán, Mexico, daughter of a German, Wilheim Kahlo, and Mathilde Calderón.

1910

Beginning of the Mexican revolution which overthrows Porfirio Diaz. Kahlo adopted this year as that of her birthday, in line with a new Mexico. Considered an accessory by her father who considered her a substitute for a son, she became his assistant in his photograph studio.

1916

Polio leaves her right leg handicapped.

1921

The Mexican government orders a large mural from Diego Rivera – returned to the country after fourteen years spent in Europe – to be sent to the National Preparatory School.

1923

Frida Kahlo enters the National Preparatory School, reserved for the Mexican elite. She was one of thirty-five girls in an enrollment of two thousand pupils. She secretly admired Diego Rivera's painting *La Création*.

1925

Frida Kahlo suffers a very serious accident. The bus carrying her is involved in a collision with a tramway. She suffers numerous fractures and internal lesions. She must remain confined to her bed, and begins to paint. Through painting, she expresses the struggle of her existence.

55. *Marxism Will Give Health to the Sick*, ca. 1954. Oil on hard fibre, 76 x 61 cm. Museo Frida Kahlo, Mexico City.

1928

Frida becomes a member of the Mexican Communist Party. She meets Diego Rivera.

1929

Frida Kahlo and Diego Rivera marry August 21.

1930

Frida Kahlo has a miscarriage in Detroit where Diego Rivera is making a fresco for the Institute of Art before working at the Rockfeller Center in New York. In September, her mother dies.

1934

The couple returns to Mexico. Diego begins his relationship with Cristina, Frida's sister. Tired of her husband's attitude, Frida Kahlo moves out and takes Isamu Nogushi as a lover.

1937

Trotski and his wife take refuge in Mexico and are welcomed at the Casa Azul. The Russian revolutionary has an affair with Frida Kahlo.

1938

André Breton comes to Mexico. The three couples have long discussions about politics and culture. Frida Kahlo has her first exhibition at the Julien Levy Gallery in New York: she is able to begin to sell her paintings. She enters into an affair with the photographer Nickolas Muray.

1939

The surrealists dedicate an exposition to her. Diego and Frida divorce in November.

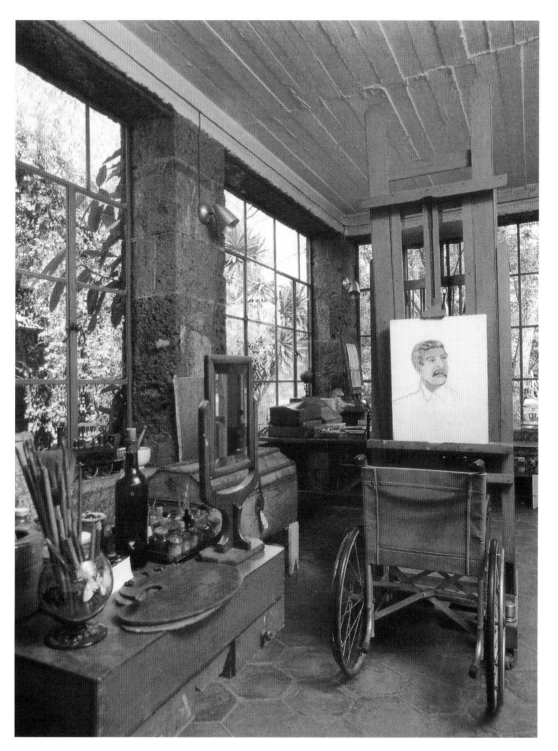

56. The Studio of Frida
 Kahlo. Photography
 by Laura Cohen. The
 studio was conceived
 and built by Riviera in
 1946. On the easel
 one sees the portrait
 Stalin that has never
 been finished.

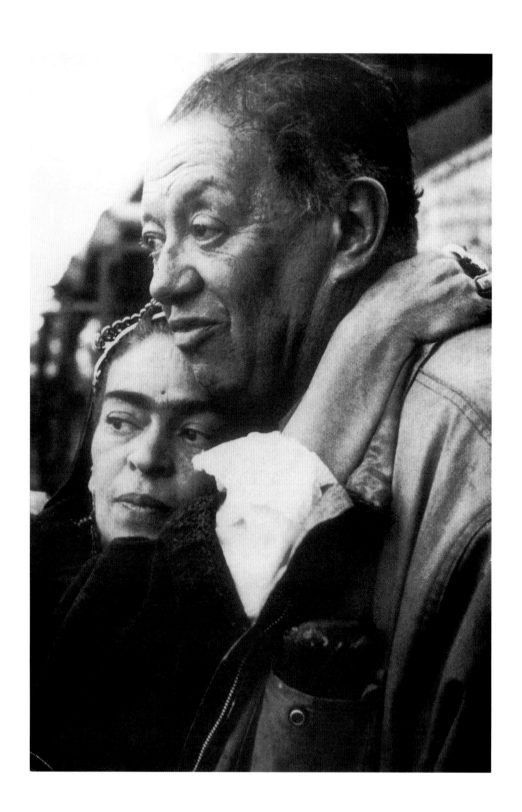

57. Frida Kahlo and
 Diego Riviera,
 ca. 1954. Photography.
 Copy edited by Kate
 Garratt, Alston (UK).

1940

Frida undergoes medical treatment in San Francisco with the help of Dr Eloesser. In August, Diego and Frida remarry.

1941

Her father dies. The couple move into Casa Azul.

1943

Frida becomes a professeur at the "Esmeralda" art school. She soon teaches at her home due to health problems.

1946

She receives the national painting prize for her *Moïse*.

1950

Her health worsens. She is subjected to nine operations for the spine.

1953

For the first time in Mexico, an exhibition is dedicated to her courtesy of Cola Alvarez Bravo.

1954

She participates for the last time in a demonstration for peace in Guatemala. Frida Kahlo dies July 13.

1959

After the death of Diego Rivera in 1957, and conforming to his wishes, the Frida Kahlo Museum opens in Casa Azul.

LIST OF ILLUSTRATIONS